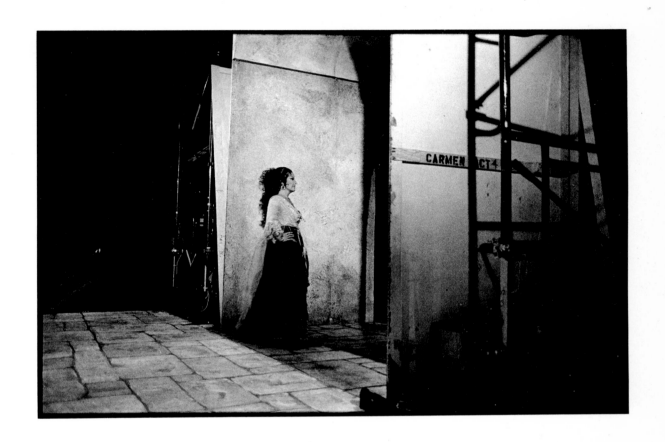

BACKSTAGE AT
THE OPERA

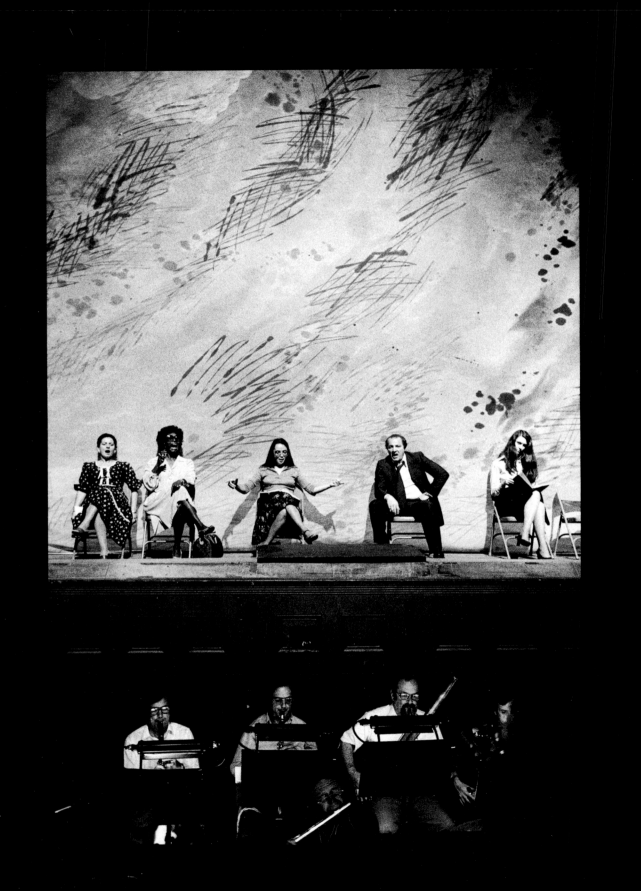

BACKSTAGE AT THE OPERA

TEXT BY JOAN CHATFIELD-TAYLOR † PHOTOGRAPHS BY IRA NOWINSKI

CHRONICLE BOOKS † SAN FRANCISCO

FOR
Kurt Herbert Adler
with respect

Library of Congress
Cataloging in Publication Data
Chatfield-Taylor, Joan.
Backstage at the opera.
Includes index.
1. San Francisco Opera.
I. Nowinski, Ira. II. Title.
ML1711.8S2S39 1982
782.1'09794'61 82-12877
ISBN 0-87701-271-7

Chronicle Books
870 Market Street
San Francisco
California 94102

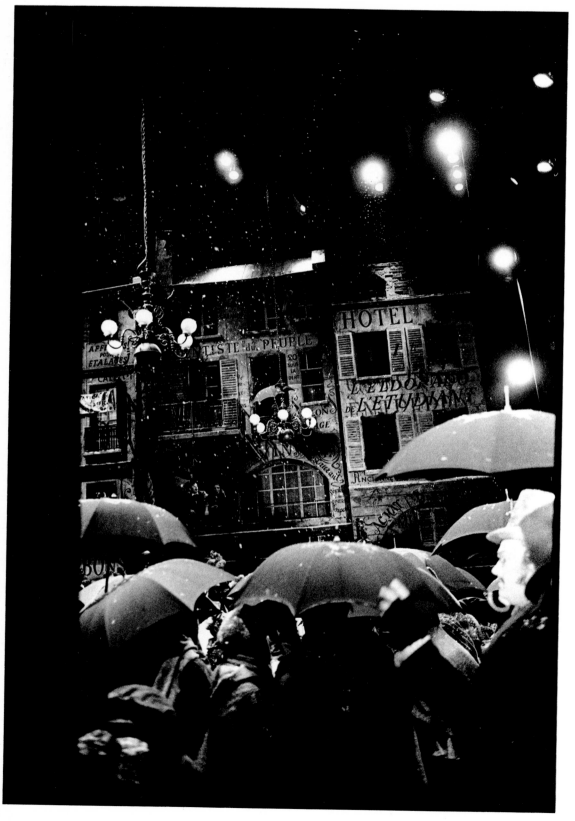

THE CONTENTS

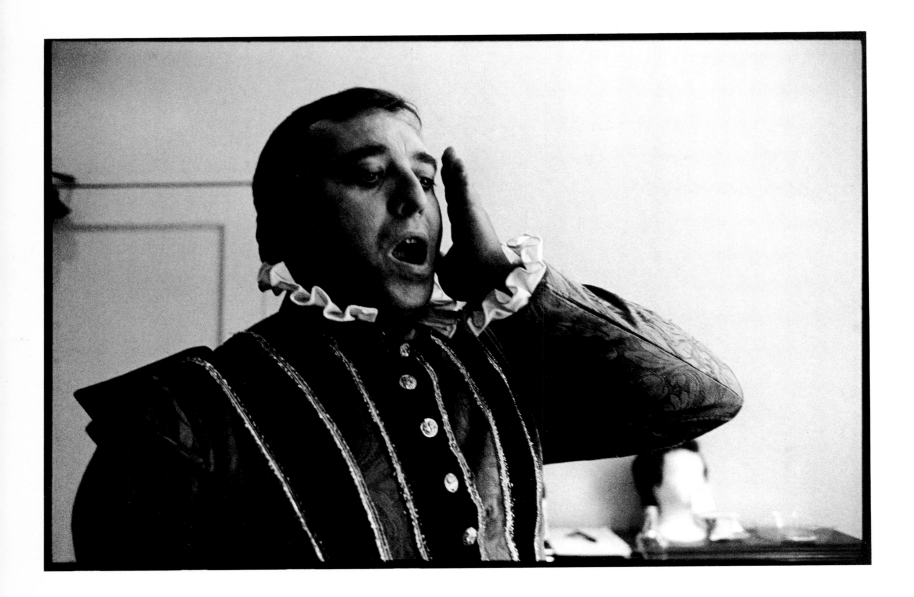

THE PREFACE

This is a glimpse backstage into one of the world's great opera houses. The setting is San Francisco, the faces some of the most famous in the world of opera. These are the singers, conductors, directors, and designers who make opera a genuinely international effort: they are jet-age nomads continually on the move between San Francisco, New York, Milan, London, Paris, and other operatic destinations all over the world.

This is also an insider's look at the process of creating what is probably the world's most complicated art form. Opera makes use of vocal and instrumental music; the poetry of the libretto; dance; and sets and costumes to appeal to audiences on musical, dramatic, visual, intellectual, and emotional levels.

Staging even one opera, much less a whole season, is a staggering project. Behind each superstar on stage is a support staff of hundreds, even thousands, of people, most of whom are highly specialized. Each production is a miraculous communion of all their efforts, in which each aspect of the work comes into balance with every other.

The logistics that produce this are as fascinating as the performance itself. In following the process, we watched productions grow from telephone negotiations through intensive rehearsals into the full-scale extravaganza the audience sees.

One might not want to become as involved in mechanics as the stage manager who said, "When I sit in the audience, I'm constantly thinking about what's happening backstage. If a wall moves, I'm wondering whether they're using a winch or thirty men to push it." Theater, after all, is a form of magic, not logic, and no theatrical form requires a greater suspension of belief than opera.

Nevertheless, the process of producing an opera, with all its attendant crises and necessary compromises, its interdependence of unique personalities and talents, makes one ever more appreciative that anything as complex as grand opera so often manages to soar above its own weight into the theatrical stratosphere.

We are both deeply grateful to Kurt Herbert Adler, the remarkable general director of the San Francisco Opera from 1954 through 1981, whose generosity and support allowed us to document a backstage world almost unknown to the public.

We wish to thank the members of the San Francisco Opera company who allowed us to watch the creative process and who spoke ardently and intelligently about their work. Joan Chatfield-Taylor's personal thanks go to Sarah Billinghurst, artistic administrator of the San Francisco Opera, and to Lotfi Mansouri, general director of the Canadian Opera Company, whose friendship and confidence were indispensable. We also want to thank Robert M. Robb and Catherine A. Joseph for their assistance in proofreading and to Lanson Moles for his assistance in printing the photographs. Ira Nowinski wishes to express his particular gratitude to all those members of the wig and makeup, costume, production, and musical departments whose enthusiasm and understanding made his intimate and informal portraits possible. Finally, we wish to thank Larry Smith of Chronicle Books who brought us together for this book.

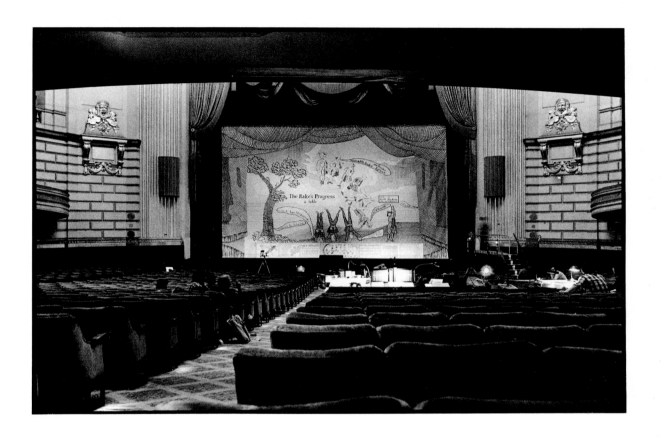

BACKSTAGE AT
THE OPERA

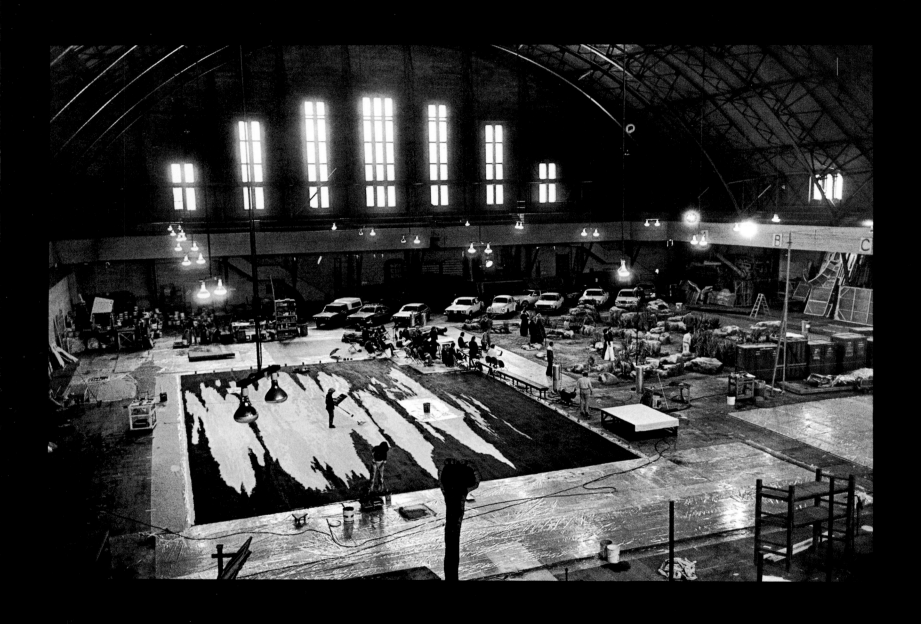

OVERTURE

Opera is a composite art form.

In the abstract, that means that it combines vocal and orchestral music, dance, and drama in a visual setting of scenery and costumes.

In human terms, it means that an opera company is a kingdom of specialists.

Take a walk through the San Francisco Opera offices on a hypothetical afternoon in spring, a few weeks before the beginning of the summer season in June. This is a fairly quiet time, before the singers arrive and rehearsals are going on night and day and everyone is feverishly doing ten things at once.

Downstairs, the War Memorial Opera House's 3,252 seats are empty, and the dressing rooms are bare and locked. On the huge stage a crew of carpenters is fitting together a set that has just arrived from London. Upstairs, the technical director is studying sketches for a new production, figuring how long it will take and how much it will cost to build the set in the opera's workshops. Next door, the lighting designer is discussing optical projectors with a photographer as they plan an illusion of shattering statues for an upcoming *Nabucco*. Around the corner in the wig department, student wigmakers are attaching bejeweled crowns to flowing wigs, while country and western music plays incongruously in the background.

On the third floor, a covey of nervous young cellists are tuning up for a final round of auditions, in which each will play a solo of his own choosing, then a few bars from *The Marriage of*

Figaro, Rienzi, and *Das Rheingold* for the resident conductor and a committee of players from the opera orchestra. Down the hall, behind the closed doors of a small coaching room, a young singer is learning a new role, working with a musical coach and a language teacher. Across the hall in the big chorus rehearsal room, the chorus is stopping and starting through *Turandot.*

Elsewhere in the building and in workshops scattered around town, librarians are marking music scores for the orchestra, seamstresses are stitching up a supply of ruffled petticoats, an administrator is arguing about airplane fares with an agent in London, the manager of the opera shop is dickering with a T-shirt supplier, the rehearsal department is figuring out the schedule for a season four years hence, and the general director is just coming back from lunch with a donor.

A major opera company is a massive enterprise. The San Francisco company's 1981 budget was $16.7 million. That year the company's year-round members numbered 263, with almost 1,000 more people hired part-time just for a season or for work on a specific opera. Typically, at least 400 people are directly involved with getting each production onstage and hundreds more are involved indirectly, providing essential support services from public relations to ushering the patrons to their seats.

Some of these people collaborate closely during the long process of producing an opera, but others meet few of their coworkers and have only the vaguest understanding of the others' specialized skills. What each shares is an intense conviction that his particular talent, whether it be putting on makeup or playing the bassoon, is a crucial piece in the giant jigsaw puzzle that is opera.

The pressure is intense. Opera staff members like to say that they present the equivalent of fifteen major Broadway musicals a year, without the luxury of months of rehearsal time and a week of preview performances. When the opera season begins, fifteen-hour days that end when the curtain falls near midnight are routine. Then the opera company becomes a hermetic world in which everyone lives, breathes, and dreams opera, working with an ardor that can perhaps only be explained by the quotation that is prominently posted in several offices:

> *Theater is a lunatic asylum,*
> *and the opera is a refuge for incurables.*
> GIOACCHINO ROSSINI

Standing at the top of the whole hyperactive, self-absorbed community is the general director. From 1953 through 1981, the San Francisco Opera was run—and personified—by

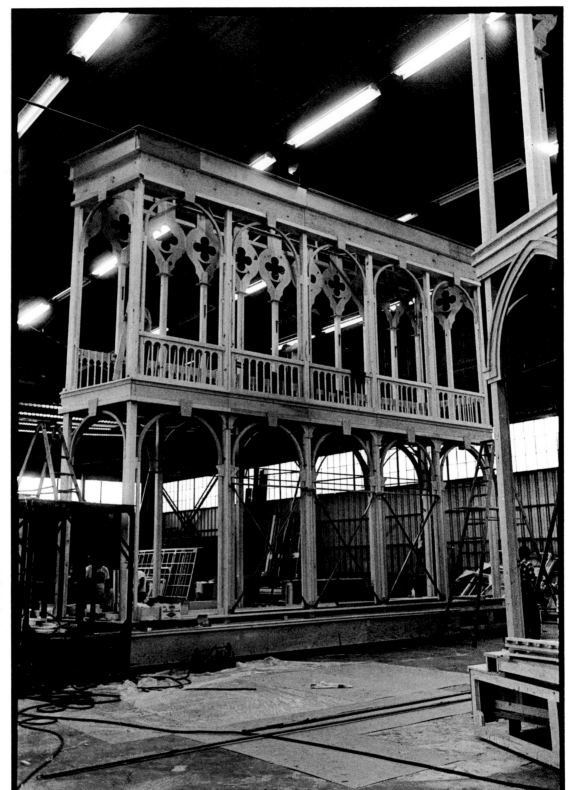

An elaborate Venetian-style gallery, strong enough to support dozens of choristers and supers, is built in the opera's huge workshop for a production of *La Gioconda*.

Kurt Herbert Adler, whose tireless, emphatic perfectionism raised the company from provincial status to a ranking among the world's most important opera houses. In January 1982 Terence McEwen, former executive vice-president of London Records, became general director, fulfilling his childhood dream of running an opera company.

The general director influences every step in the process of opera making. He or she chooses the repertoire, hires the singers, approves the stage director's ideas and the set designer's sketches, arbitrates the conflicts, and coordinates the whole massive, collaborative effort. No detail is too small; from the cuts in the score to the spears carried by the supernumeraries, the general director has the final word.

An opera season is born in the mind and pockets of the general director. Both Adler and McEwen have been known for jotting down ideas for repertory, ideas for casting, ideas for scenery, ideas for everything on bits of paper. Eventually, the notes come out of the pockets and turn into memos and letters and telephone calls and staff discussions and, in their final written forms, contracts.

AN EVOLUTIONARY PROCESS

Planning the season is an evolutionary process, lasting as long as five or six years, in which money, taste, sentiment, personality, timing, and luck influence artistic decisions. The primary step, theoretically, is to decide which operas to perform, not only in the summer and fall seasons but in the shorter, smaller-scale affiliate programs. In San Francisco, a typical season might include works by Verdi, Wagner, Mozart, Strauss, and, perhaps, Puccini. An eighteenth-century work and a contemporary opera usually are included, with something French and something Russian to add spice to the Italian and German basics.

Opera seasons are subject to fads and phases. Opera companies all over the world suddenly decide to revive a rarity like Massenet's *Thaïs,* or the tide swings to Rossini's comedies or Donizetti's queens. An eye must be kept on the box office, even in San Francisco, where the opera plays to 98-percent-of-capacity audiences, a majority of whom are season subscribers. Some years the public flocks to Wagner, other years they stay home when Wagner is featured. Even the tried and true war-horses, such as *La Traviata* and *Carmen* and *La Bohème,* have to be chosen with care.

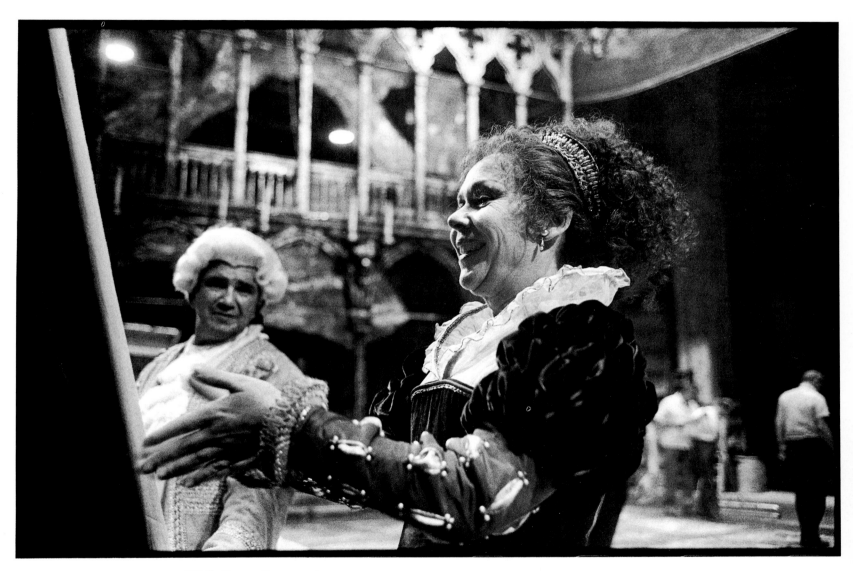

While Renata Scotto waits
to take a curtain call
between the acts in *La
Gioconda*, the stagehands are
already busy dismantling
the set and pulling up the
tacks that hold the canvas to
the floor.

Too many *Aida*s in a decade, and the fans begin to get restless. To emphasize the festive quality of the fall season's most gala night, the opening-night opera is usually short and melodic.

Logistics and finance, as well as aesthetics, make a balanced operatic menu essential. If too many operas have major chorus parts, the choristers will be underrehearsed and overtired by mid-season. The choral weight of *Nabucco* and *Lohengrin* must be lightened by the likes of *Wozzeck,* with a handful of chorus members, and *Die Walküre,* with none.

The rehearsal time and sheer endurance of the orchestra also must be considered. How many of the operas will be new to the musicians? How many will require exceptional rehearsal time? How many operas will require an enlarged orchestra? Removing the first two rows of seats to make room for Wagner's and Strauss's extra musicians is a costly decision.

How much preseason time will be needed for technical rehearsals, the lengthy sessions in which the sets are put up on the stage and the lighting is planned? Because the number of weeks that the stage is available are limited, operas involving elaborate sets and complicated lighting schemes must be balanced with technically simpler operas that require less preseason work.

The choice of repertoire often comes down to what sets and costumes are already available. In San Francisco, the company has some 150 productions—sets and, in some cases, costumes—stored away in warehouses. Some are operatic history; the set for the 1932 production of *Tosca,* given at the opening of the opera house, is still there. Roughly a third of the sets are still up-to-date and in good enough condition to be revived, perhaps with some cosmetic changes and a new lighting plan.

San Francisco's company creates two, three, or four new productions a year, with an eye on both expanding the repertoire and keeping up a stock of the basics. If currently no usable *Tannhaüser* is tucked away in a warehouse, that may be reason enough to schedule a *Tannhaüser.*

Finances are also a factor in choosing new productions, because for each opera the physical trappings—the sets and costumes—cost anywhere between $75,000 and $500,000. Some operas, such as some twentieth-century works, can be presented in low-budget settings, but a major international opera company must do *Aida* in grand style or not at all. The cost of grandeur may be for lavish costumes or elaborate sets or dramatic special effects; there are no bargain-basement collapsing temples for *Samson et Dalila.* Other operas strain budgets with the amount of rehearsal time they require, the number of extra choristers, or the number of stagehands that will be necessary.

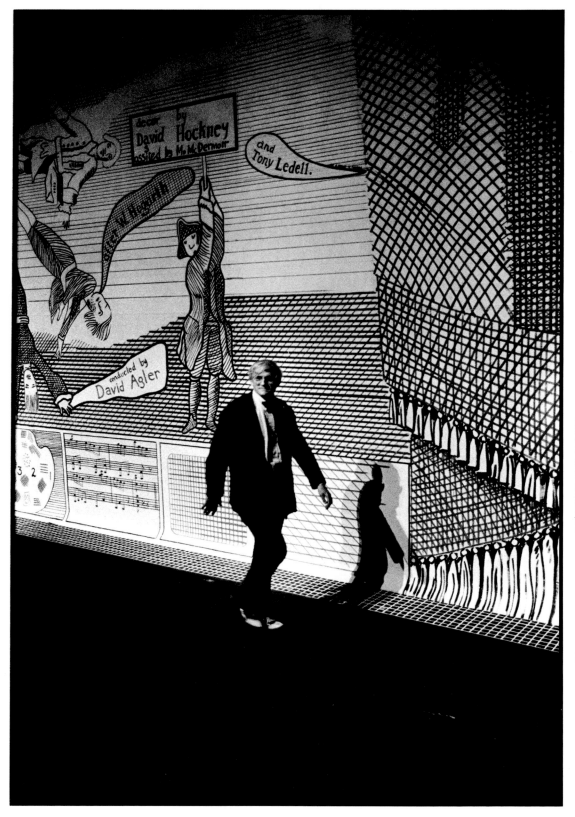

British artist David Hockney has had remarkable success when he has turned his hand to stage design. Here he walks in front of the drop curtain that he created for Stravinsky's *The Rake's Progress*, inspired by William Hogarth's engravings.

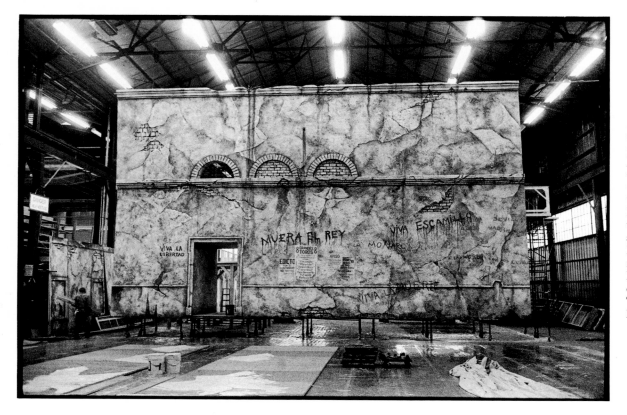

A wall painted with graffiti and splashed with posters (left) was the centerpiece of Jean-Pierre Ponnelle's design for a production of *Carmen*. The set was built in the opera's workshops from Ponnelle's sketches, then set up in the rehearsal hall for staging sessions in which Ponnelle (right) showed mezzo-soprano Teresa Berganza, playing Carmen, exactly what he wanted. Tenor Franco Bonisolli looked on.

New productions are usually paid for by individual donors, who may also have something to say about the operas they wish to underwrite.

Increasingly, owing to financial pressures, opera companies are sharing productions, either by sharing the initial expense or by buying, renting, or trading sets and costumes from other companies. The trend is not without controversy; in spite of the financial savings, opera experts worry that sharing productions inevitably means a loss of artistic control, as opera companies commit themselves to using productions that were created for other houses with different requirements and standards. The shipping of costumes and sets also means considerable wear and tear and a shorter life for the production.

Once a repertoire is provisionally in mind, it is time to hire the artists. At least, that is the theory. In fact, the choice of singers often comes first, especially in the current era of superstars. If an opera company wants the likes of Montserrat Caballé and Marilyn Horne, it had better be prepared to offer them the operas they want to sing. If Luciano Pavarotti decides to sing his first Radamès and wants to do so in San Francisco, then *Aida* suddenly becomes an attractive possibility.

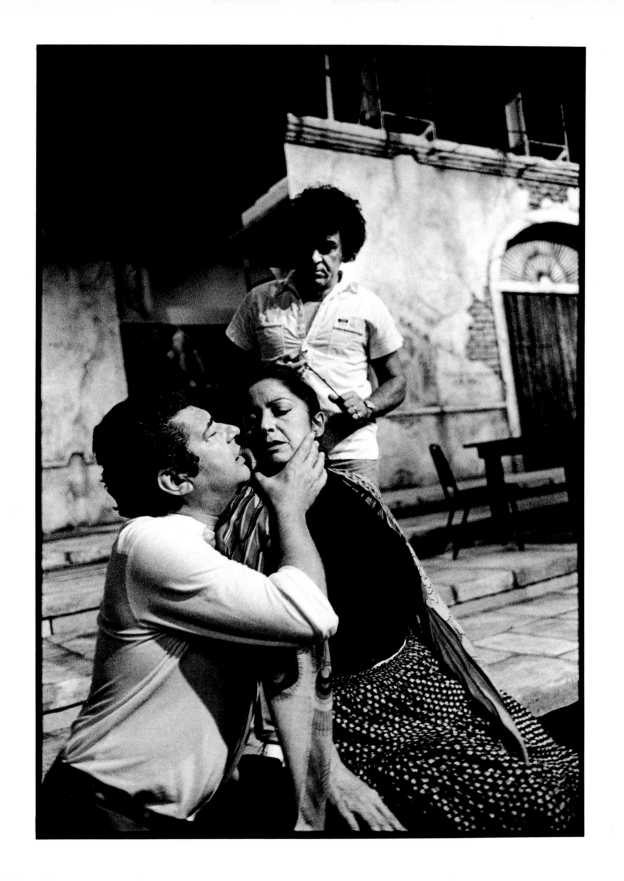

Great voices are not sufficiently plentiful to go around, particularly since the recent blossoming of opera companies both in America and in Europe has increased the competition for the best singers. Hiring major singers four and five years in advance is now routine, despite the concurrent risk that the performer will lose his voice in the meantime – and refuse to admit it.

Whenever opera people gather, there are endless discussions about singers. The tone is often irreverent, but the intent is serious, as administrators, directors, and agents compare notes about performances all over the operatic world and exchange opinions about singers and their potential in certain roles.

The flourishing of opera has made the search for new singers more important than ever. The San Francisco Opera, under Kurt Herbert Adler, has been praised for discovering many singers and giving them their American debuts in major roles. Adler searched for new names in newspaper reviews and musical publications. He listened to a small handful of people, among the hundreds who had opinions and suggestions, whom he trusted to look and listen and give reliable information. He made frequent trips to Europe, attending performances every night and conducting auditions by day, ever hopeful of finding undiscovered talent. Adler's giving an American debut to soprano Birgit Nilsson before he had to compete for her services with every other major opera company was more than a matter of saving money on fees. From contract negotiations through rehearsals and performances, personal relationships are often crucial to the success of an opera company. A singer who makes a debut with a particular company often feels a special loyalty and may return to try out new roles or help out in an emergency.

Once the major roles are filled, it remains to choose singers for the lesser parts, the ones known as *comprimario* roles. These include most of opera's numerous messengers, jailers, nurses, maids, sergeants, and masters of ceremony. The parts range in size from two-liners, such as the role of the messenger in *Il Trovatore* (which consists entirely of singing *"risponda il foglio che reco a te,"* followed by *"corro"*), to difficult ensemble singing, such as the quintet in *Carmen*, and even to sizeable solo roles, such as that of Beppe in *I Pagliacci*.

In San Francisco the comprimario roles are almost always filled by young singers who are participants or recent graduates of the company's various affiliate programs. They gain vocal and stage experience by singing in as many as six operas during a season. For some, the comprimario roles are a transition to principal roles. Other singers never graduate to stardom but make solid operatic careers out of the secondary roles.

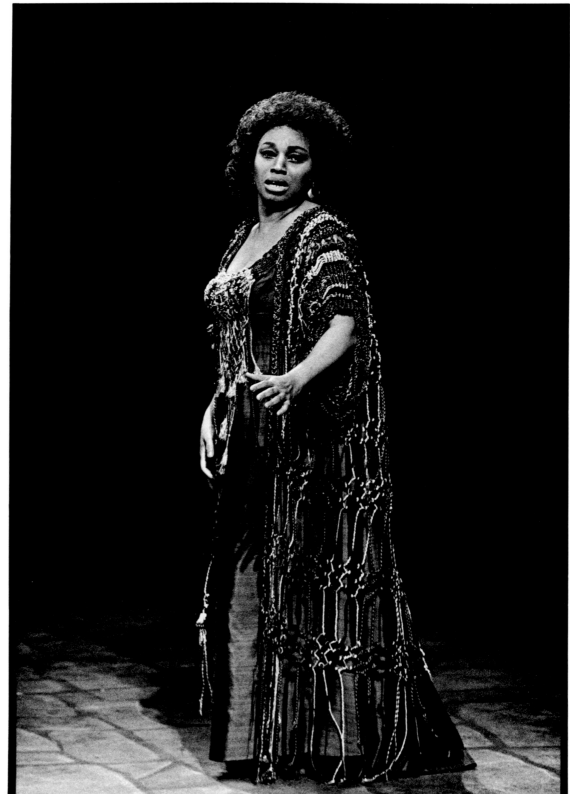

When soprano Leontyne Price stepped in as a replacement in one performance of *Aida* during the fall season of 1981, there was rare silence and attentiveness in the wings, where the backstage crew got this view of the historic performance.

At all levels, casting is more than a search for a perfect voice. The key word is ensemble, with each performer chosen to complement the others. One cast might be chosen with an emphasis on acting ability, and a magnificent voice without dramatic talents would be out of place. Another cast might be chosen purely for vocal talent. Some operas, because of their vocal demands or their obscurity, demand superstars. Others thrive on younger, less masterly singers, as anyone who has wept at a student performance of *La Bohème* would testify.

The voices themselves must fit together, as well. Auditioning singers together is usually impossible, if only because artists are scattered all over the globe, but the general director must hear in his mind what his chosen Don Carlos and Rodrigo will sound like long before they begin rehearsing their powerful duets.

The very size of an opera house may limit the choice of singers, as in San Francisco, where filling the house's million cubic feet of space with sound is a dangerous, if not impossible, effort for many young singers. There are experienced singers, too, with successful careers in Europe's physically smaller theaters, who would be lost in the vastness of the War Memorial.

One final element in putting together a balanced and harmonious cast—an element more elusive and unpredictable than

For the principals, the rehearsal process starts with musical rehearsals. Here, Gwyneth Jones, pencil in hand to make corrections in her score, prepares for a 1980 production of Wagner's *Tristan und Isolde*.

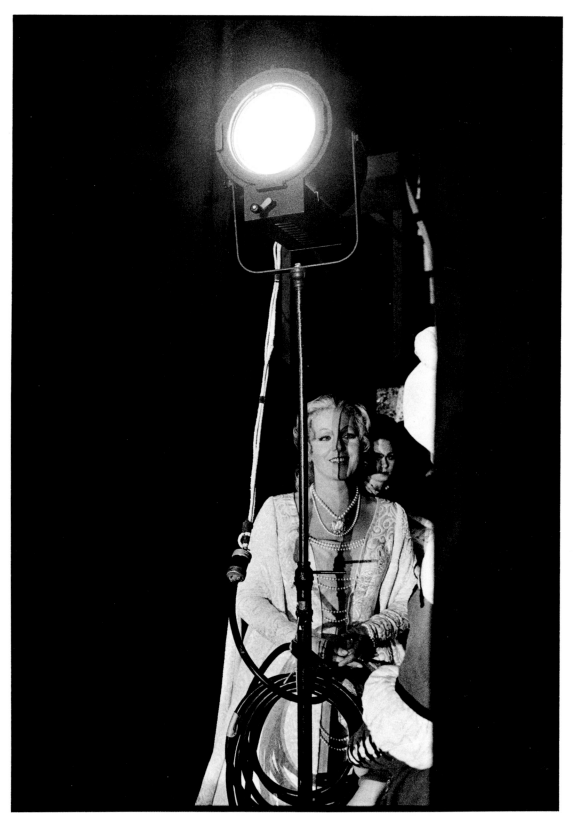

Soprano Katia Ricciarelli
waits by a sidelight at stage
left for her next entrance as
Desdemona in a 1978
production of Verdi's *Otello*.

vocal talents—is personality. Opera is a collaborative effort, made easier if the protagonists have a happy rapport. Some major singers, directors, and conductors have already discovered that they do not have it, and they refuse to work together. Aside from the well-known feuds, trying to figure out how people will get along when they finally meet for rehearsals is usually a fruitless task. The cast that everyone expects to be serenely congenial promptly blows up in a tempest, while another group, thrown together by chance, works peacefully and productively.

No matter how carefully the choices are made, the best-laid plans often go awry in the opera world. From the moment that a singer agrees to sing until the final performance, the possibility exists that the singer may cancel.

The company may decide to do *The Marriage of Figaro* because a certain soprano is available to sing the role of the countess. A few months later, she cancels. By then, *Figaro* is part of the balance of the season, other artists have been engaged, and the search is on for a new countess.

Pregnancy has been responsible for some cancellations. Some singers have changed their minds about wanting to do the roles. The most common excuse (one that has been used as long as a year in advance) is illness. Often, given the fragility of the human voice, the illness is real.

Even when singers arrive in town and are rehearsing, the fear that they may cancel is ever present. San Francisco has traditionally lived dangerously by not always hiring covers, as the understudies are known. Some of the last-minute substitutions have been breathtaking. Opera fans treasure the memory of Leontyne Price stepping in as Aida and of Wagnerian tenor Jess Thomas rushing in twelve minutes before the curtain to sing a triumphant Siegmund in *Die Walküre*.

On rare occasions, a total unknown has gotten a chance to sing unexpectedly. When Montserrat Caballé became ill after singing one performance of Donizetti's *Roberto Devereux*, opera staff members spent most of a frantic weekend calling all over the world in search of a soprano to sing the obscure and demanding role of Elizabeth, Queen of England. When none was available, a young local singer was pushed into action. She studied the role for two days, put on her wig and costume for the first time, and went out to sing without benefit of a full rehearsal with the entire cast.

Besides the singers, there are directors, conductors, set designers, costume designers, lighting designers, choreographers, assistant conductors, and prompters to be hired from the outside or chosen from the opera company's own staff. At this

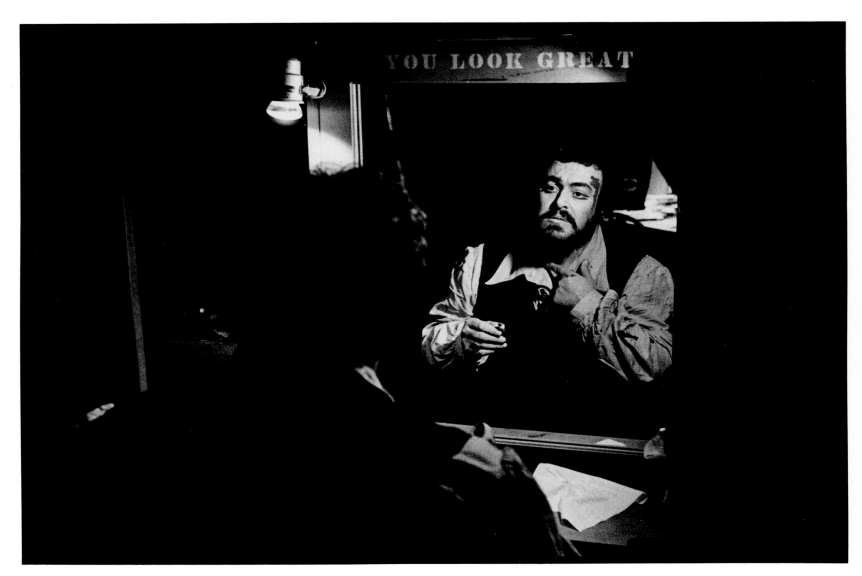

In the second act of *Tosca*, while the character Cavaradossi is being tortured by Scarpia's men, tenor Luciano Pavarotti is just offstage, looking in a mirror as he applies the requisite "blood"—a startling red toothpaste he provides himself.

point, there may be some consultation with those already hired: a director may be asked his opinion on the choice of set designer or singers, and singers may be asked whether they prefer to work with specific conductors. If feasible, their ideas will be taken into consideration as the hiring process continues. That's not always easy. Typically, Tenor A expresses his liking for three conductors and Soprano B names her favorites, one of whom the tenor has stated he doesn't like. A couple of conductors are acceptable to both of them, but one is not available and the other doesn't like the opera in question. The search continues. Hundreds of phone calls, telegrams, and letters later, the team takes shape.

The opera negotiates hundreds of individual contracts each season. Singers' fees are closely guarded secrets, but major singers are reportedly paid from $1,000 a performance to a top fee of $8,000, plus air fare. The prestige of the opera company is a factor in the haggling over fees; the most prestigious houses, the ones that offer the greatest exposure to the artists, usually pay less, not more, than lesser companies. The performance fees are considered to include payment for the weeks that the performers are required to be present for rehearsals. San Francisco's top fees are reportedly lower than the fees that the same singers receive in Europe's more generously subsidized opera companies.

The singers who are paid per performance traditionally receive their money immediately after the curtain goes down, when a staff member goes from dressing room to dressing room passing out checks. The tradition has been somewhat eroded by modern tax practices; these days many singers are incorporated, and their fees are sent elsewhere.

Most comprimario singers are hired on a weekly contract basis, and their minimum salaries are based on the American Guild of Musical Artists' classification of their roles as bit, supporting, or featured.

THE CONCEPT

Opera, at the level of a major international company, is a global effort. The singers are gypsies, constantly on the move, singing in all the important opera houses. Increasingly, the singers fill out their operatic schedules with performances all over the world: concerts, television appearances, movies, and recording sessions. Making travel arrangements and finding temporary housing for this

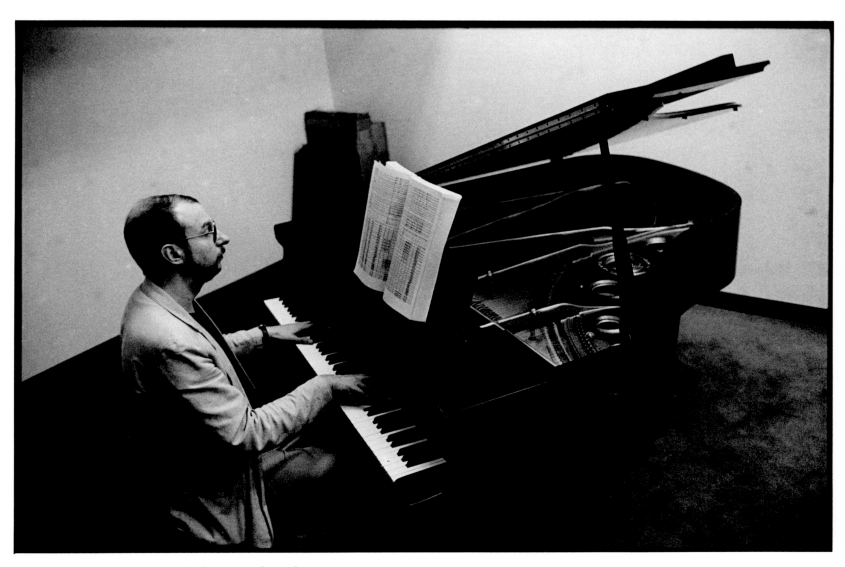

During most rehearsals, a
piano represents the orches-
tra; here composer Aribert
Reimann plays the storm
scene from his *Lear*.

hyperkinetic group is a full-time job for an opera company staff member.

It is not only the singers that give opera its international flavor. The specialized talents of set designers, stage directors, conductors, costume designers, and prompters transcend all language barriers and keep these people on the move, too. Six months before the curtain rises, it is conceivable that the set designer is finishing up his sketches in New York, the costume designer studying swatches in Stockholm, the stage director working on cuts in the score in Sydney, the conductor studying the score in Rome, the prompter signaling from the prompter's box at the Metropolitan Opera in New York, the assistant conductor playing the piano for a rehearsal in Lyon, and the singers performing in Hamburg, Milan, Chicago, and London.

Typically, the first people to work together are the director and the set designer, who meet in a convenient location – San Francisco, New York, or wherever else in the world they both find themselves – to develop what opera people call the concept.

The concept establishes the general feeling of the production. The first thing that the audience will see is the setting, usually before a note has been sung, and that initial visual impact should convey the stage director's ideas about the essence of the opera.

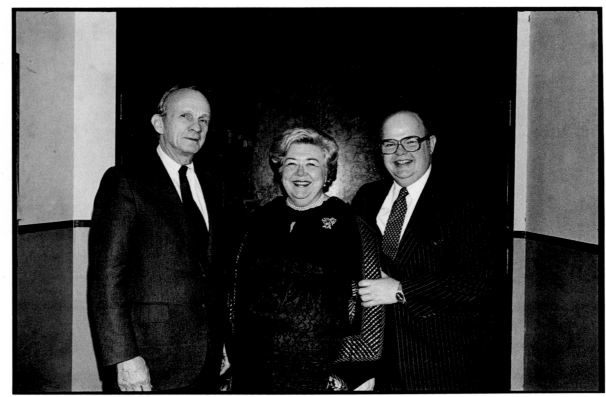

A trio of general directors, Anthony Bliss of New York's Metropolitan Opera, Ardis Krainik of the Chicago Lyric Opera, and Terry McEwen of San Francisco, pose backstage during a performance of *Carmen*.

Italian stage director and set designer Pier Luigi Pizzi leans back against the white molded plastic columns that he created for a 1981 production of Rossini's *Semiramide*.

Together, stage director and set designer have considerable range in creating a mood for the production. They may opt for elaborately detailed realism or choose a stylized or abstract setting. They may devise an intimate and homely setting that suggests the common humanity of the protagonists, or they may emphasize grandiose or mysterious elements of the music and plot. Even in the case of a comedy, they may choose a cheerful, stylized setting or a more subdued or realistic set that suggests tragicomedy.

Money may be a factor in the deliberations; realism generally costs more than abstraction. To stay within a budget, the stage director and designer may use a unit set—a single construction that can be adapted to each scene or act—rather than different sets.

The concept may be an attempt to duplicate exactly what the composer is believed to have wanted. Many tradition-minded productions are based on contemporary accounts of the original performances and on the detailed staging directions written by such composers as Verdi and Wagner.

To the far left, so to speak, of this conservative approach are the radical reconceptions of operas. In these, the originals are transposed to different settings and time periods, with plots rewritten and characterizations changed, usually with the idea of lending contemporary meaning to the work. Given enough leeway, an audacious director can stage an *Aida* with a tomb scene located in a World War II gas chamber rather than an Egyptian pyramid.

Once the director and the set designer (who may in some cases be the same person, as with the multifaceted Jean-Pierre Ponnelle) have agreed on a concept, they present it to the general director. This meeting often includes the opera company's technical director and the conductor, and it, too, may take place anywhere in the world that is convenient. Presentations range from detailed drawings and diagrams to quick sketches bolstered by art books that suggest the look the director and designer have in mind.

Once a general concept has been determined, other people can begin working. The costume designer, lighting designer, choreographer, and wig and makeup designers begin making their own sketches and plans, conferring with each other during the year before the season through an endless series of letters, telegrams, drawings, meetings, and telephone calls.

Also, once the concept has been determined, set construction can begin. In the San Francisco company's huge workshop on Indiana Street, a team of specialized carpenters, sculptors,

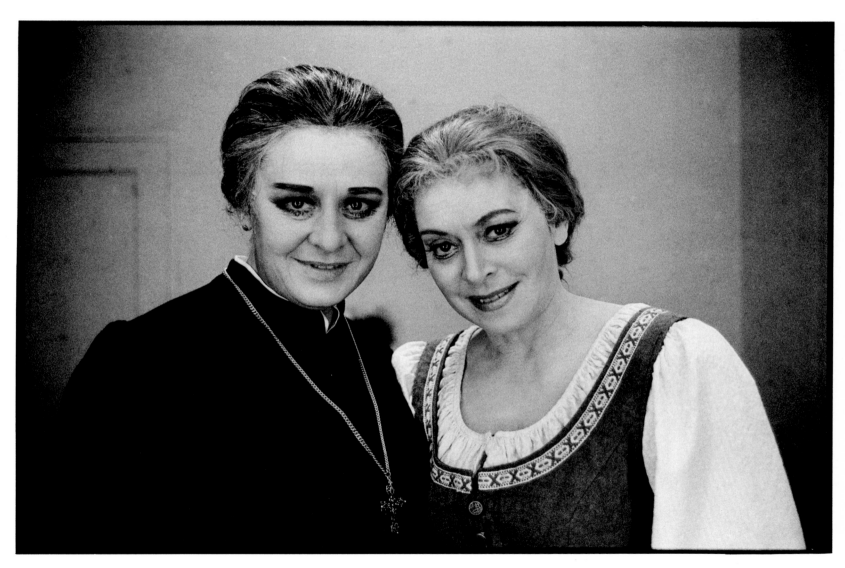

Sena Jurinac, dressed in black for the role of Kostelnička, and Elisabeth Söderström, in peasant garb for the role of Jenůfa, wait in the dressing room during a performance of Janáček's *Jenůfa*, which they sang in the original Czech.

and painters begins building the sets for the new productions. Some of the craftsmen have been working there for decades, and they point out that many of the sets must be more solidly and intricately built than the average house, because the sets have almost no right angles, and standard-sized elements can rarely be used. A balcony may have to support fifty or sixty chorus members, and a mountain of rocks may have people climbing up and down it. Complicating the construction, every set must be divisible into pieces that are manageable by the stagehands.

Over the past decade, there has been a trend toward more substantially built sets. A column that might once have been skillfully painted on a flat backdrop of canvas now is likely to be sculpted of plastic, covered with gauze, and painted.

In the early days of the opera, sets were often pastiches. A colonnade from one opera plus a tower from another plus an interior scene from another added up to a quick if not spanking-new production. Now sets do not do double duty, but props still do. Regular operagoers would feel right at home in the part of the Indiana Street warehouse where the props are stored. Some of the hundreds of chairs, tables, sconces, chandeliers, spears, halberds, swords, beds, and chaises longues have made so many appearances in different operas that they seem like old friends, even well disguised by new paint and upholstery.

A LIFETIME COMMITMENT

Far from San Francisco, the singers begin to prepare their roles. For them, each new major role is a lifelong commitment. If all goes well, they may be singing the part for twenty or thirty years in dozens of different productions.

The more thoughtful artists may start their preparation by doing considerable research before they begin working on the music itself. The original story that the libretto was based on, the composer's original staging directions, and descriptions and pictures of the first production of the opera may be available as sources of inspiration. For *Carmen*, for instance, the original Prosper Mérimée short story, detailed descriptions of the first production (supervised by Georges Bizet at the Opéra-Comique in Paris), and contemporary paintings of Spain by Gustave Doré are available.

The curtain is still down, the orchestra is playing, and sopranos Pilar Lorengar, at right, and Anne Howells have taken their positions onstage for a performance of Mozart's *Cosi fan Tutte*.

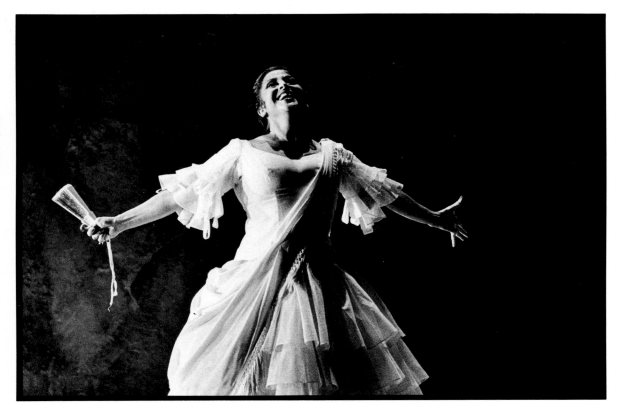

Spanish mezzo-soprano
Teresa Berganza was dressed
in ruffled white organza
for the final dramatic act
of *Carmen*.

Some singers develop deep personal involvement with specific roles. Teresa Berganza, preparing to sing Carmen for the first time, spent hours in the gypsy quarters of Seville, studying the way the gypsy women move. For her, she has said, there was also the particular involvement of portraying the freedom-loving Carmen at the same time that Berganza herself was creating a more independent life. Rebecca Cook, preparing the role of Micaela in the same opera, visited Lourdes, the Catholic shrine in the Pyrénées between France and Spain, and watched the young girls who push the wheelchairs of invalids, comparing them to the pious peasant girl she would be playing.

Once the singers have their characters in mind, they begin working on the music with their own vocal coaches. Some singers attend performances of the opera and listen to records of those who have done the roles, but others carefully avoid listening to existing interpretations.

34

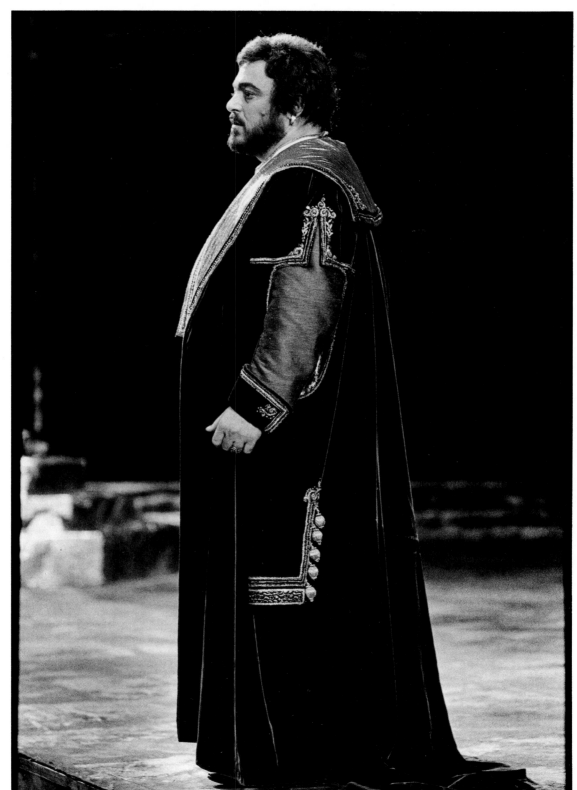

One of Luciano Pavarotti's favorite costumes is the opulent, gilded velvet robe he wore as Enzo Grimaldi in *La Gioconda*. His costumes, designed by Zack Brown, were among the most expensive ever worn on the opera-house stage, costing more than $5,000 each.

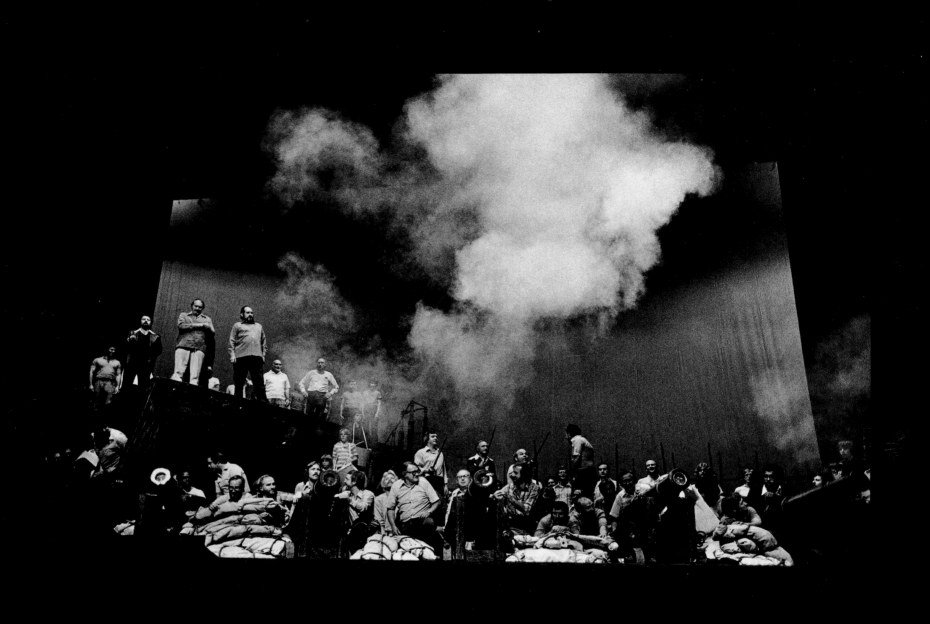

REHEARSAL

An opera's early preparations are scattered, separate, often solitary efforts that may stretch over the better part of a year. Less than a month before opening night, rehearsals start, all the disparate elements begin to move into place, and the real collaboration begins.

Opera is too cumbersome and too multifaceted to be rehearsed as one organic whole. It would be instant pandemonium to summon principals, choristers, dancers, and supernumeraries onstage all at once and shout "okay, everyone, let's start with act 1!" Instead, opera is created in layers and segments. Each element—vocal music, orchestral music, principals, chorus, ballet, supernumeraries, lighting, and scenery—is rehearsed separately.

The separate elements are combined and recombined in varying ways during the series of different types of rehearsals, with everything finally coming together at the final dress rehearsal, a few days before opening night.

The process is like putting together a collage. As each element is added, the design becomes a little richer, although not until the last piece is put into place and the lights are turned up full is the final effect apparent. Each type of rehearsal hints at the whole, but, until the final dress rehearsal, too much is missing for most observers to visualize the performance.

Months before the singers assemble, the staff tries out the sets on the opera-house stage and plans the lighting. This is the technical rehearsal. Patient volunteers called light-walkers, representing the performers, stand immobile on the stage for hours on end, staring out at the empty seats. Barely visible in the darkness are the director, set designer, and lighting designer; they sit at a long desk in row M of the orchestra seats and try various lighting effects. The information is then fed into a computer that controls the lights during the performance.

The director, set designer, and lighting designer start by creating an atmosphere for the production, a visible expression of the music—subtle and romantic for *Pelléas et Mélisande*, stark and contrasty for the atonal music of Aribert Reimann's modern opera *Lear*, and bright and cheerful for *The Barber of Seville*. Strong downward lighting can be used to suggest sadness and tragedy, literally giving the performers long and shadowed faces, while bright and even lighting immediately sets the mood for comedy.

The plot helps define the style of lighting. In a 1981 production of Shostakovich's *Lady Macbeth of Mtsensk*, the chorus members on the outer fringes of the crowd were in darkness, suggesting that they were anonymous observers of the central drama. In Benjamin Britten's *Peter Grimes*, the chorus is central to the drama, representing the forces of conformity that eventually drive Grimes to suicide, and each chorister's angry expression must be visible.

Once the general mood for the opera has been set, the lighting designer begins to highlight specific dramatic moments. One of the easiest tricks is to gradually lower the background lighting as a singer goes into a major aria. The visual distractions disappear, the audience's eyes automatically focus on the performer, and, ideally, the change is so subtle that no one is conscious of it.

Some operas have only one or two lighting changes per scene, others have as many as three hundred. Up to six hundred lights may be used, consuming as much power for each performance as the average household uses in six months. Computers register the location, focus, intensity, and color of every light in the house. During the performance a single electrician

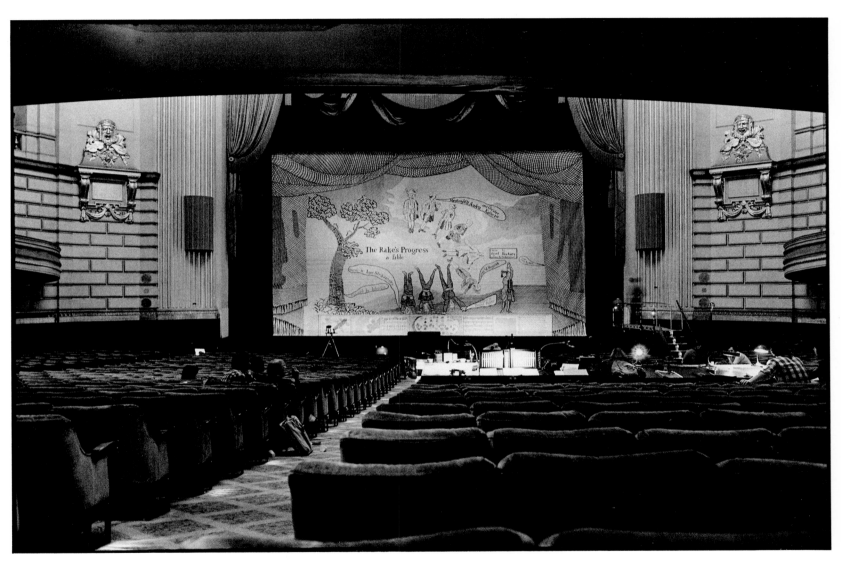

During technical rehearsals, the opera house is almost empty except for a long desk set up in the middle of the orchestra seats for the director, set designer, and lighting designer. Here, the stage is set for a lighting rehearsal of *The Rake's Progress*. Typical of today's well-traveled productions, David Hockney's sets were originally created for Glyndebourne in England, recreated for the larger stage of La Scala, and finally brought to San Francisco for yet another appearance.

activates the computer, creating lighting effects that once would have required ten men and hours of rehearsal time. The computer makes it possible for complicated lighting effects to follow each other in quick succession or to overlap, so that the sun can be setting on one part of the stage while singers in a darker area of the stage can be spotlighted.

A mixture of space-age technology and ordinary magic tricks is responsible for some of opera's most spectacular visual effects. High-intensity lighting has made it easier to create bold swathes of color and light onstage. Much of it was originally developed for other industries; airport runway lighting was responsible for the brilliant glare in *Lear*. In a 1979 production of *Pelléas et Mélisande*, no painted sets were used at all; instead, twenty projectors with high-intensity bulbs threw patterns and color onto a series of scrims and nets.

Modern lighting can simplify some of opera's most difficult staging directions, the ones that casually instruct, for example, "The temple must collapse." When Nabucco ordered the pagan idols to disappear in a recent production of the Verdi opera, the idols did indeed seem to shatter, but it was all done with slides rapidly moved in large projectors.

Nonetheless, lighting cannot do everything. One director had to be told that a red set could in no way be made to look

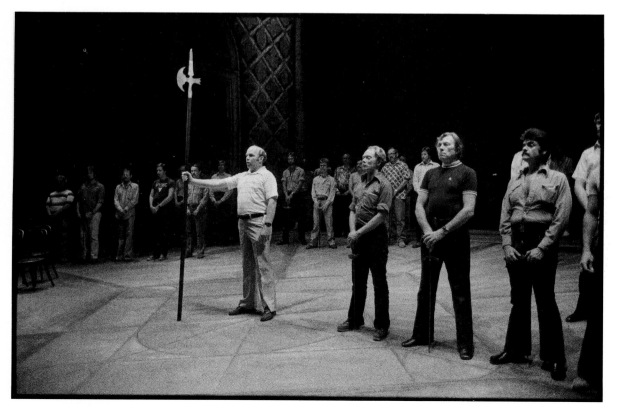

Without the grandeur of costumes and with only a lone halberd as prop, Allan Monk and members of the San Francisco Opera Chorus strike heroic poses during a staging rehearsal for a 1978 production of *Lohengrin*.

High-intensity airport runway lights were added to the opera house's usual array of lighting equipment to create the blinding brilliance that director Jean-Pierre Ponnelle wanted for the last thirty seconds of *Lear*.

blue. Sometimes lighting schemes go awry because of human factors. Singers are supposed to sing their arias where the light was focused during rehearsals, but some performers never sing from the same place twice. Some gravitate inexorably toward center stage, no matter what the director has in mind. Others react like moths to a lantern, instinctively moving into the brightest light even when it is contrary to the dramatic action.

THE PRINCIPALS ARRIVE

Three weeks before opening night, the principals come to town and rehearsals begin in earnest. The time span may seem short, but rehearsals are scheduled morning, noon, and night, seven days a week.

Keeping track of all the rehearsals, which start as early as ten in the morning and run as late as eleven at night, is a nightmare that only a computer could love, particularly in midseason. Then, as many as six operas are in rehearsal or performance.

Take an average day during the fall season of the San Francisco Opera—say Tuesday, October 6, 1981. On that day, onstage, the chorus and the orchestra participated in one of the final runthroughs of *Carmen* in the afternoon and performed *The Merry Widow* in the evening. Upstairs on the third floor, there were musical rehearsals for the principals in *Lady Macbeth of Mtsensk* and a special session for *Carmen*'s offstage musicians. Down the street in the new rehearsal hall, staging for *Wozzeck* was just getting under way. In an upstairs conference room, a two-hour production meeting for *Le Cid* was scheduled. In the coaching rooms, nine singers worked on their roles in *Die Walküre, Wozzeck, Carmen, Le Cid,* and *Lucia di Lammermoor.* It was a quiet day in one respect; no costume fittings had to be squeezed into the schedule.

The juggling of schedules is a full-time job for three people in the rehearsal department. They make sure that no one is asked to be in two places at once, and they make sure that everyone turns up at the right place at the right time, politely telephoning every principal singer, conductor, and director to remind them of rehearsals and performances. These three also keep track of a maze of union regulations that governs everything from the time that orchestra rehearsals must begin to the number of consecutive days each singer has worked (because the American

Soprano Leonie Rysanek
takes a break during staging
rehearsals for a 1979
production of Richard
Strauss's *Elektra*.

Guild of Musical Artists forbids its members to work more than twenty-two days in a row). They regularly cope with last-minute changes that turn the neatly printed master schedule into a fiction. A director decides to rehearse a different act, a singer has a cold, a conductor wants more rehearsal time with the orchestra.

The rehearsal department acts as the unofficial nerve center and funnel of gossip for the whole opera house during the season. Its staff is often the first to hear if a singer is ailing. Its two small rooms are tucked next to the stage door, where everyone goes in and out. Late in the evening, almost everyone in the company drifts in to pick up a copy of the next day's schedule. The singers' flowers and messages are kept there, as is a sternly guarded Rolodex with the local telephone numbers of every performer.

The rehearsal department speaks its own language, an efficient code of letters, numbers, and symbols in which a piano dress rehearsal is described tersely as the PCA+ (P for piano, C for chorus, A for artists, and the plus sign for sets, lights, costumes, and makeup). When opera people talk about rehearsing scene forty-two, they're not referring to the longest opera ever written. In the rehearsal department's code, scene forty-two means act 4 scene 2. Scene eleven is act 1 scene 1.

About a month before each opera's opening night, rehearsal-department gossip turns to new arrivals. Yes, Miss Caballé is in town. No, Margaret Price isn't here yet, but she is scheduled to arrive in two days. Mr. Bonisolli will arrive in time for a Friday night rehearsal if his plane from London isn't late.

MUSICAL REHEARSALS

Once artists, conductor, and director are in residence, safely lodged in hotel rooms and rented apartments, the tempo picks up.

The next step is musical rehearsals, the initial contact between singers and conductor. Opera singers are supposed to arrive with their music and text perfectly memorized (although this is not always the case). In the musical rehearsals, the individual sounds become part of a musical whole; the performers adapt their voices to the others' and make adjustments to fit the conductor's ideas on tempo and dynamics, the variations in speed, and the volume of the music.

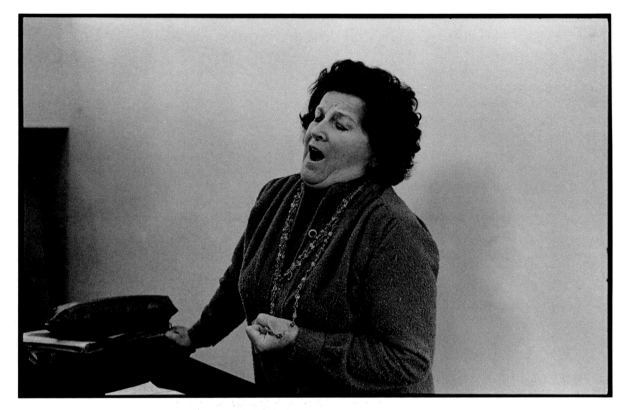

Even without sets, costumes, orchestra, and audience, the great stars of opera bring all the emotional intensity of their roles to every rehearsal session. Birgit Nilsson's fierce concentration is obvious as she clenches her fist and leans against the piano in a 1979 musical rehearsal.

At the first musical rehearsal for a production of *Semiramide*, conductor Richard Bonynge, soprano Montserrat Caballé, and mezzo-soprano Marilyn Horne discuss the embellishments each singer will add to the score of Rossini's bel canto opera.

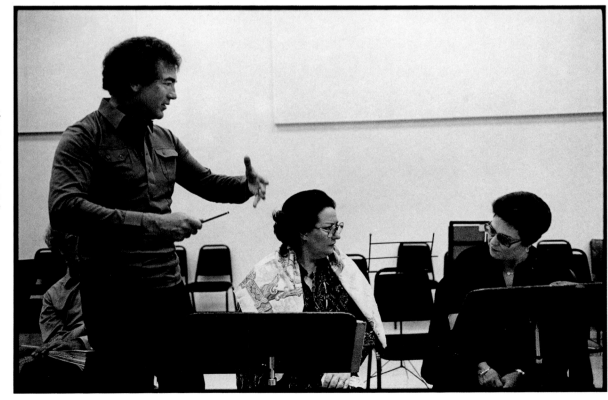

If the singers have rehearsed or performed different versions of the opera, they correct their scores and check the cuts that are planned for this particular production. Although the current trend is to perform operas in their entirety, conductors and stage directors do sometimes delete music from original scores for reasons that may be musical, dramatic, or as simple as wanting to shorten an opera that would otherwise require considerable overtime pay for artists, musicians, and stagehands. In some cases, different versions of a score coexist. For instance, Verdi wrote both five-act and four-act versions of *Don Carlos*, and producers must choose how much to include. The original Opéra-Comique production of *Carmen* included both spoken dialogue and some music that were later deleted; the more familiar version features sung recitatives written after Bizet's death.

Opera people reminisce about the old days when such conductors as Bruno Walter and Arturo Toscanini spent months coaching singers individually. Today, opera is part of the jet age. Movement means money, and the time that singers and conductor have together is far shorter.

Still, three weeks before opening night, there is time to discuss the smallest musical details—when to take a breath, whether to imply a comma in a phrase, how to pronounce a word.

The conductor may discuss the orchestral accompaniment with the singers, particularly if they are preparing their roles for the first time. The singers and conductor decide on embellishments—the optional vocal frills—while the prompter and the rehearsal pianist take careful note.

"Do you want a diminuendo on '*froid*'?" asks soprano Rebecca Cook, preparing to sing her first Micaela in *Carmen*.

"It's not just me who wants it. It's Bizet who wants it," responds Kurt Herbert Adler, the conductor. "And I need a sixteenth rest here. It gives a certain vitality when you get these things right, and that's why I take my time with them."

Musical rehearsals have an intimate, cozy feeling. It is a small group, a handful of people hardly large enough to fill up a corner of the big chorus rehearsal room. Besides the singers, who are rarely all together at the same time, and the conductor, three important people who are never seen by the public attend musical rehearsals.

The first of these is the prompter, probably the most misunderstood person in opera. During the performance, he or she works in a five-foot-wide box that protrudes a few inches above the downstage floor near the proscenium. In that dark hole are a

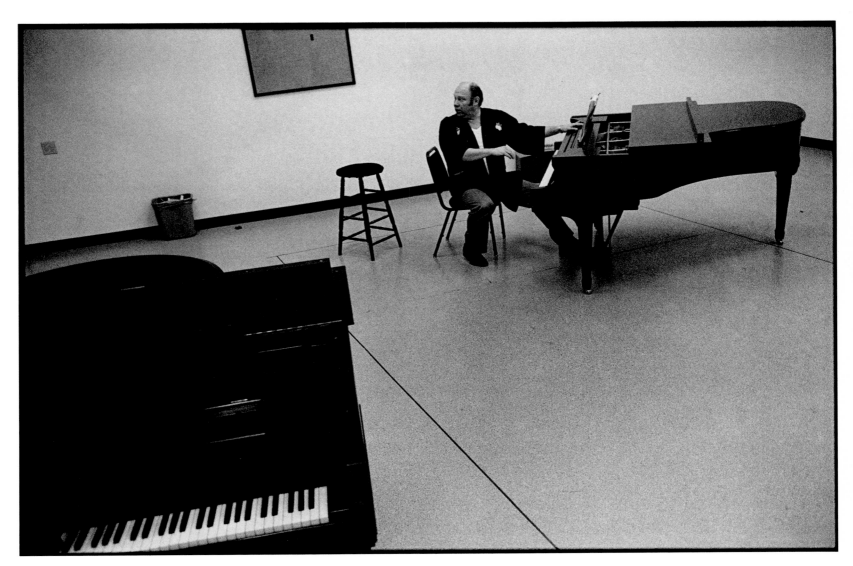

Ingvar Wixell chooses a piano in a rehearsal room during the hour before curtain time, when some singers like to practice for a few minutes. He is due soon to be made up for his role as Mandryka in Richard Strauss's *Arabella*.

stool, a lamp, a closed-circuit television that gives a close-up view of the conductor in the pit, a loudspeaker that amplifies the orchestra, a telephone, and a fan that makes a feeble attempt at ventilating the airless space. The box may not be pretty, but prompter Susan Webb describes it as the best seat in the house.

If the audience members think of the prompter at all, they are likely to assume that he or she is the operatic version of the theatrical prompter, calling out a line only when someone has obviously forgotten what is next. In Germany and Austria, the prompter traditionally reacts only when a performer has a lapse of memory, but the Italian style of prompting used in San Francisco and at the Metropolitan Opera in New York is a far more complicated process. Veteran prompter Philip Eisenberg says firmly, "I'm one of the most important people here, right along with the director, the conductor, and the artists."

The prompter speaks the start of each line, reminding the singers not only of words but of timing and pitch. Using sounds (Eisenberg favors a clucking sound, a bit like someone trying to communicate with a parakeet), eye contact, or hand signals, the prompter warns singers just before they are to sing. If a singer is off pitch, the prompter sings out or signals with a finger pointing up or down. Watching the television monitor, he conveys the tempo to singers who often cannot hear the orchestra per-

Prompter Philip Eisenberg is invisible to the audience, but the singers get a clear view of him in his box just in front of the footlights. The prompter is the preventive medicine of opera, cueing each singer's attack, keeping everyone on the correct pitch and tempo, and reminding the performers of forgotten words and stage directions.

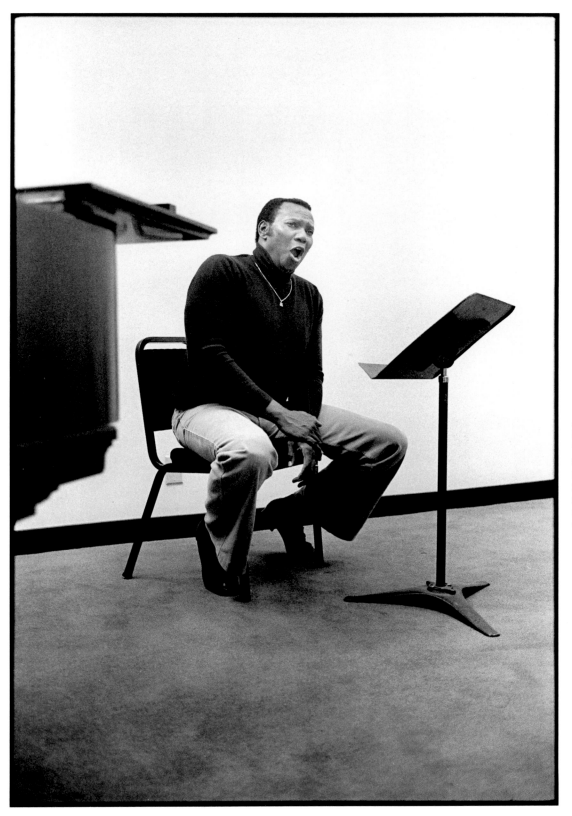

American bass-baritone Simon Estes rehearses for *Tristan und Isolde*. Opera singers prepare their roles on their own and then begin to work together during the musical rehearsals that usually start three or four weeks before opening night.

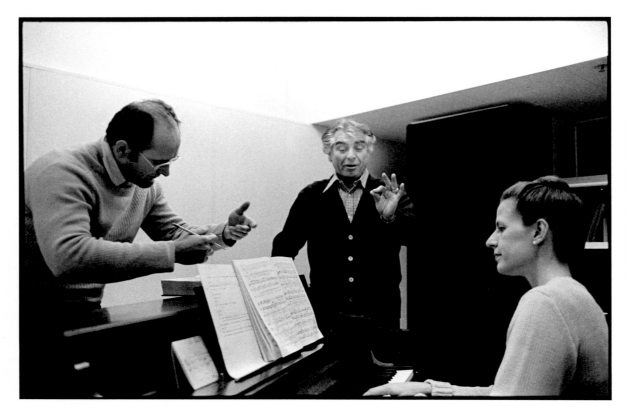

Pianist Martha Gerhart works with conductor Uwe Mund and bass Geraint Evans on a 1980 production of Donizetti's comic opera *Don Pasquale*. The pianist, officially known as an assistant conductor, plays the music, coaches the singers individually, conducts backstage music, and is indispensable at almost every rehearsal.

fectly and may not be able to see the conductor's hands clearly.

The operatic voice is so massive a musical instrument that even with loudspeakers in the wings to amplify the accompaniment, a performer in full cry may not be able to hear the orchestra. So for tempo and pitch, singers may find it more reliable to depend on the prompter than on their own ears.

Turning the pages of the score, glancing from stage to monitor to music, signaling with hands and fingers, making sounds and speaking lines, a prompter in action is not a peaceful sight. The prompter may also have to deal with the unexpected. Eisenberg once saw Beverly Sills's hem catch between the floorboards in front of the prompter's box. Just before she was to turn and sweep imperiously upstage, he reached out and freed the skirt. Susan Webb became adept at fending off Christmas packages flung in her direction by Musetta in the second act of *La Bohème*.

The prompter is opera's insurance policy against disaster. In the legitimate theater, if an actor forgets a line, he may be able to cover up for a few seconds, conjuring up a bit of stage business or even making up a line or two until he remembers the

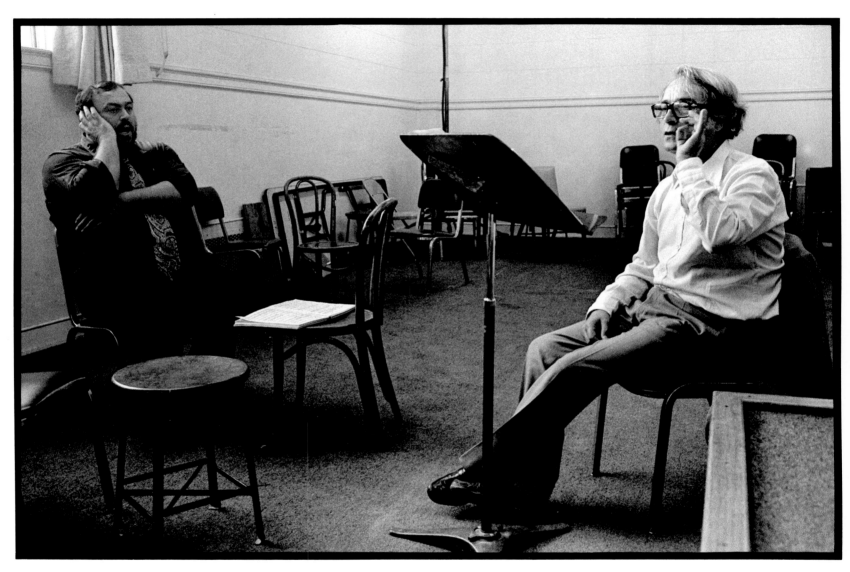

Luciano Pavarotti, about to
sing the role of Enzo in *La
Gioconda* for the first time,
begins working with con-
ductor Bruno Bartoletti at
the first musical rehearsal.
Singers doing a role for the
hundredth time may need
only one or two rehearsals
with the conductor, but
many more musical rehear-
sals will be scheduled for an
artist working on a major
role for the first time.

script. Opera doesn't offer this kind of leeway. No matter what is happening onstage, the music surges ahead, leaving no room for improvisation.

Most singers appreciate the prompter's help. A singer's repertoire may include between twenty and a hundred or more roles, some of which he sings only rarely. And some roles, in like style or by a single composer, resemble each other so much that mixing up words or cues is easy. To complicate things further, singers perform the same roles in more than one language. Put all these factors together, add a little jet lag felt by late-arriving singers, and it is easy to see why they feel more confident when a competent prompter is in the box.

The prompter works every rehearsal as if it were a performance, giving the cues and becoming familiar with the conductor's ideas on tempo, with the onstage action, and with the singers' individual preferences and problems. Some singers want to hear just the first word of the line; others want three or four words. Some want the cue a beat ahead; some, half a beat.

The second unknown soldier is the rehearsal pianist. For the three weeks of rehearsals, he or she will represent the orchestra, playing the music at exactly the tempo the conductor wishes. The job requires stamina, musical talent, and a healthy ability to read minds. The last is important because singers react as soon as they hear a note, so the pianist can keep up a brisk pace in rehearsals by sensing exactly where the director wants to start up after each interruption.

When the pianist is not playing for formal rehearsals, he acts as an assistant conductor, coaching the singers individually. Once performances begin, he may be in the wings conducting offstage music.

Also present at every rehearsal is a language coach, making sure that every word is pronounced exactly the way the librettist and composer intended. Thanks to the efforts of these diction coaches and to each singer's acute ear and gift for mimicry, listeners are seldom jarred into an awareness that operatic performers are frequently singing in languages they don't speak.

It doesn't matter, coaches point out, whether a tenor can order dinner in French; all that counts is that he sounds French onstage. In fact, language teachers sometimes have an easier time getting the right sound out of singers who do not speak the language and therefore have no bad pronunciation habits.

Because opera rehearsals are often a Babel of languages, the diction coach also acts as a translator, explaining a foreign-language libretto to chorus and supernumeraries and acting as linguistic go-between for members of the cast without a common language.

Soprano Leonie Rysanek and conductor Janos Ferencsik study the score during musical rehearsals for a 1978 production of Richard Strauss's *Der Rosenkavalier.*

Renata Scotto, surrounded by empty chairs in the chorus rehearsal room, sings forth during preparations for *La Gioconda*. In the informal atmosphere of the first musical rehearsals, the massive, disciplined sounds of some of the world's greatest operatic voices filling the room come almost as a shock.

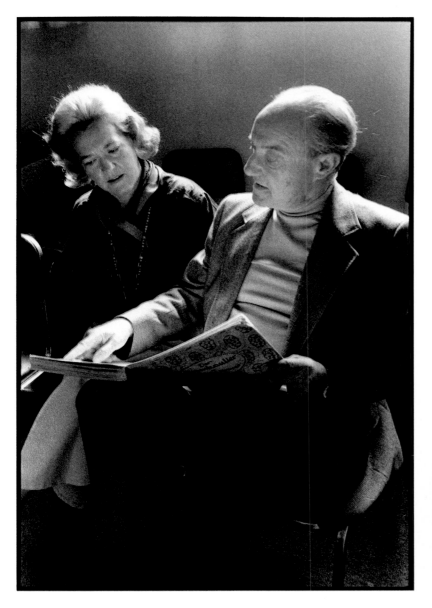

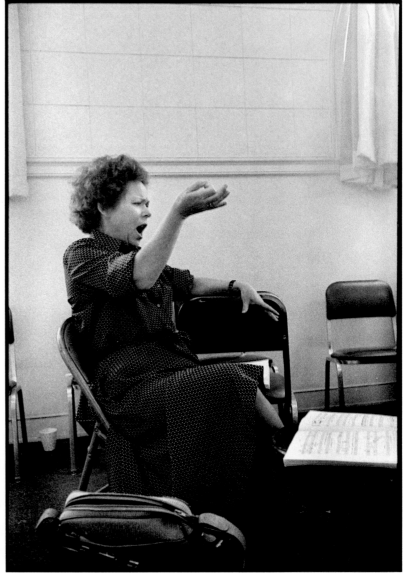

Musical rehearsals are highly informal concerts. In contrast, staging rehearsals, the next step in the process of opera making, create the entire theatrical experience.

There is a tremor of anticipation as everyone assembles in the rehearsal hall for the first time. The bare bones of the first-act set have been set up—a section of medieval tower, a wall, or a gypsy caravan, just enough to tell the performers the pitch of the stage and the location of steps and doors. In San Francisco, rehearsals begin promptly; ten minutes before the scheduled hour, the director is reviewing notes while a hierarchy of assistant directors, stage managers, production assistants, and stagehands are bustling about unfolding chairs, counting props, and arranging tables and music stands.

The conductor, rehearsal pianist, language coach, and prompter arrive and open their scores. The understudies settle themselves to wait patiently in the background. Finally the singers arrive, casually dressed, carrying canvas bags stuffed with scores and thermos bottles of tea.

For some, the first staging rehearsal is a reunion with old friends, veterans of other productions and other opera houses, and it begins with a flurry of hugs and kisses and greetings in several languages. At the first staging rehearsal for a production of *Il Trovatore*, Leontyne Price looked across the room at mezzo-soprano Fiorenza Cossotto and said affectionately, "You know, Fiorenza and I go back a long way together—Verona, 1959—and when we see each other now, it's just as if the conversation had never stopped."

For other members of the company, the first rehearsal begins with a round of introductions. Occasionally, the director and conductor are meeting for the first time. The singers may not have met before even though they have crisscrossed the same continents and sung in the same houses for years.

This is the moment when everyone sizes each other up, sometimes literally. A statuesque soprano carefully appraises her colleagues and comments cheerfully, "A tall tenor and a tall baritone—things are looking up." This is also the occasion for some subtle jostling for position. One director compares it to the first day of school, when you have to show everyone you know what's what. His favorite technique is to arrive with an ancient,

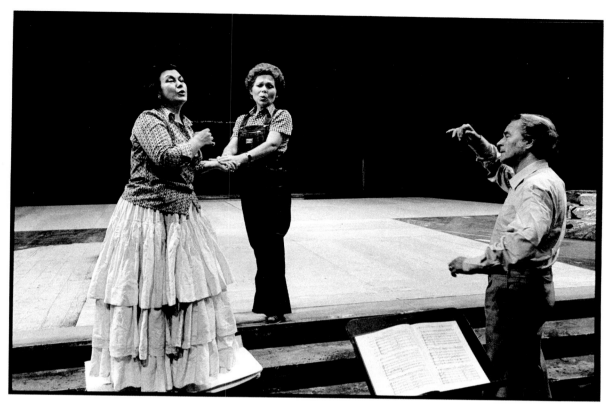

Renata Scotto and Margarita Lilova (left) sing an emotional duet from *La Gioconda* for Bruno Bartoletti, who, as conductor, is always present at rehearsals, although the director is in charge of staging them. At another rehearsal (below), stage director Lotfi Mansouri acts out a role with Scotto while Lilova observes. Lilova is wearing one of the rehearsal skirts provided by the costume department for singers who want the feeling of the period costumes they will be wearing during the performances.

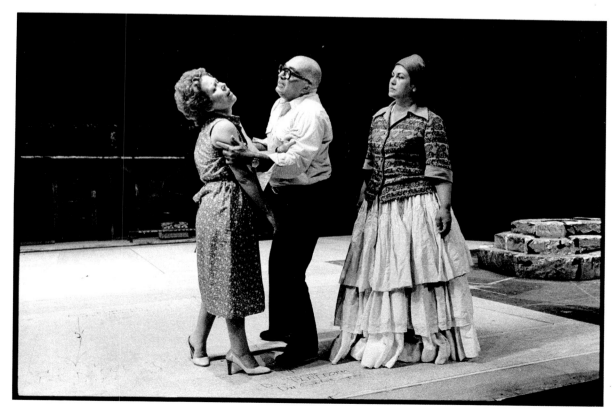

Tenor Spas Wenkoff kneels on the rocky third-act set during a staging rehearsal of *Tristan und Isolde*. Although the full panoply of sets and props is not yet available, enough is provided in the rehearsal hall for singers to get used to doors, steps, the slant of the stage, and other elements of the landscape.

even offend, takes out his frustration on the performers who have no clout.

No formula guarantees success. A serene, harmonious rehearsal period may be followed by thrilling performances—or may not. Some casts spend three weeks in gritty, acrimonious conflict and then walk out onto the stage to perform in perfect harmony—and others do not. Kurt Herbert Adler, a veteran of hundreds of productions, has said emphatically, "There are a great many ways to reach a goal."

SCENE BY SCENE

The ideal opera stage director is a Renaissance man who reads music and speaks English, German, Italian, and French. He or she is blessed with taste and imagination and has a firm grasp of the psychological, social, visual, and metaphysical aspects of the opera at hand. He understands the singing voice, knows how to get hundreds of people on and off a

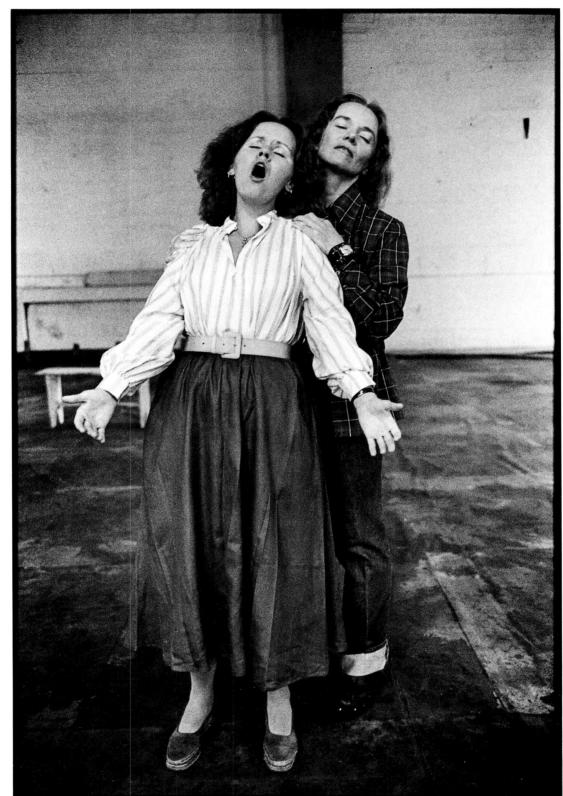

Although staging rehearsals don't look particularly operatic, the gripping emotion of the music is always present. Here soprano Ruth Welting, with director Ghita Hager, sings out during a staging rehearsal for *Don Giovanni*.

stage in seconds, and can inspire artists to act as well as sing. He can handle prima donnas and is knowledgeable about lighting, sets, costumes, and makeup.

Not many of these paragons exist, and those who qualify are among the busiest people in the world, flying endlessly from La Scala to the Metropolitan to Covent Garden to San Francisco, settling for three or four weeks at a time to create a production, staying to take a quick bow on opening night, then flying onward.

A few decades ago, the director was considered clearly subservient to the conductor; the director was a traffic cop who made sure that the singers did not bump into each other onstage. More recently, as the opera world has aspired to offering more complete theatrical experience and singers have been praised for subtle, psychologically motivated acting, the opera director's stature has grown.

On the first day of staging rehearsals, the director is the only person with a clear idea of what the opera is going to look like onstage. He has only a few weeks to turn his ideas into reality, building up the action in layers and segments.

He works scene by scene. He starts with the principals and the comprimario singers, discussing their characterizations and movements. Blocking sessions, in which characterizations and stage directions are worked out in detail, alternate with run-throughs of entire acts and scenes, which establish the timing and continuity. The chorus and the supernumeraries are rehearsed separately, so that superstars are not standing around idle while spear carriers are persuaded to march in unison. When principals and chorus first are brought together, a little ceremony marks the moment: each principal, no matter how many times he or she has sung with the company, is formally introduced to the chorus, which traditionally responds with a patter of applause.

At the director's side is an assistant stage director, taking notes. One of the assistant's most important tasks is to compile the production book, a detailed description that includes the position of every performer in every scene. The next time the opera is scheduled, the book will be checked to see exactly what props are necessary, how many supers have been used, and all the other practical information needed to restage the production. If the production is sold or loaned to another opera company, the production book will be sent along with the sets and costumes. The assistant stage director, who is often a prospective director, is also responsible for keeping up the standard of the production in the performances after the director leaves.

Stage director Lotfi Mansouri, head of the Canadian Opera Company, has worked in San Francisco many times over the years. His most recent productions there include the 1979 *La Gioconda*, the first San Francisco Opera to be nationally televised; the 1980 *Don Pasquale*; and the 1981 *Il Trovatore* and *The Merry Widow*.

Operatic directing is a constant juggling of the visual and vocal, the dramatic and musical. For instance, a director might find it aesthetically pleasing to divide up a chorus of soldiers according to height. But for musical reasons blocking is usually done according to vocal groups. Platoon A will therefore be first tenors, followed by platoons of second tenors, baritones, and basses.

The music sets the pace, and the action must fit it as precisely as choreography. A movie director can film a sword fight and then choose music to highlight the clash of metal. In opera, the fight must fit the music. To make sure that it does, a fencing coach may be brought in to teach performers to lunge and parry gracefully and to choreograph sword strokes that end on precisely the right note.

To further complicate opera direction, the singing swordsmen must be placed so that they can fight with vigor and watch the conductor at the same time. Singers, fighting or not, must have almost constant visual contact with the conductor or prompter if they are to sing on cue and keep to the right tempo. They must be placed on the stage so that they can at least glance sidelong toward the orchestra pit, the prompter's box, or the closed-circuit television monitors focused on the conductor and hidden in the wings.

Directors also have to deal with singers' precise ideas about what they will and will not do while singing. Some will not run. Some will not sing lying down and insist on being propped up even as they languish into melodramatic death. Monumental arguments have exploded when a director suggests that a dramatic scene be played upstage in a corner. It may be partly the ego of the prima donna that makes a singer insist that the scene be played center stage, but it is also worry that the voice will not project as well from farther back.

Although opera singers invariably claim to love the combination of music and theater, their dramatic abilities vary considerably. Most owe their careers primarily to their extraordinary vocal abilities, not their acting talent. Many have never had an acting lesson; even the most comprehensive operatic training programs do not always require attendance at acting classes.

For most singers, acting is secondary to the effort of producing a unique sound that is possible only through their conscious control of muscles, breathing, and placement of jaw, tongue, and palate.

Some singers have magnificent voices and almost no dramatic talent. Other singers can act when they are not actually singing, and there are a rare few who act and sing at the same

Bass Geraint Evans is Don Pasquale during a staging rehearsal for the Donizetti opera. In the background, staging director Lotfi Mansouri and assistant stage director Virginia Irwin watch.

The youths of the San Francisco Boys Chorus, dressed in their regulation red T-shirts, surround bass Federico Davià. Davià is rehearsing the role of Alcindoro in the Ponnelle production of *La Bohème*, while assistant stage director Nicolas Joël gives instructions. The San Francisco Boys Chorus and Girls Chorus San Francisco are often called in by the opera to lend both their voices and their animation to operatic crowd scenes.

Soprano Montserrat Caballé
and tenor Luciano
Pavarotti join hands during
a rehearsal of *Tosca*.

time, underlining the impact of the music with a more intimate communication. Directors talk lovingly and longingly about them, calling them singing actors and naming Placido Domingo, Elisabeth Söderström, Teresa Stratas, and Tatiana Troyanos as examples.

The very size of some opera houses, including San Francisco's, makes most subtle acting impossible. The artfully raised eyebrow and the expressive wink are lost in the vastness where the stage itself measures more than 15,000 square feet and the performers are 170 feet from the people sitting in the last row of the balcony.

The language barrier also contributes to broad acting. Because only a small percentage of American operagoers understand what is being sung, the acting must sometimes be broad to help the audience understand how the plot is unfolding.

At any rate, too much realism and subtlety would often be inappropriate to an art form in which people sing rather than talk, and in which fratricide, suicide, and madness are routine. Opera, after all, is supposed to be larger than life, its drama and raw emotion flanked on one side by sex and violence and on the other by choral grandeur the Catholic Church might envy.

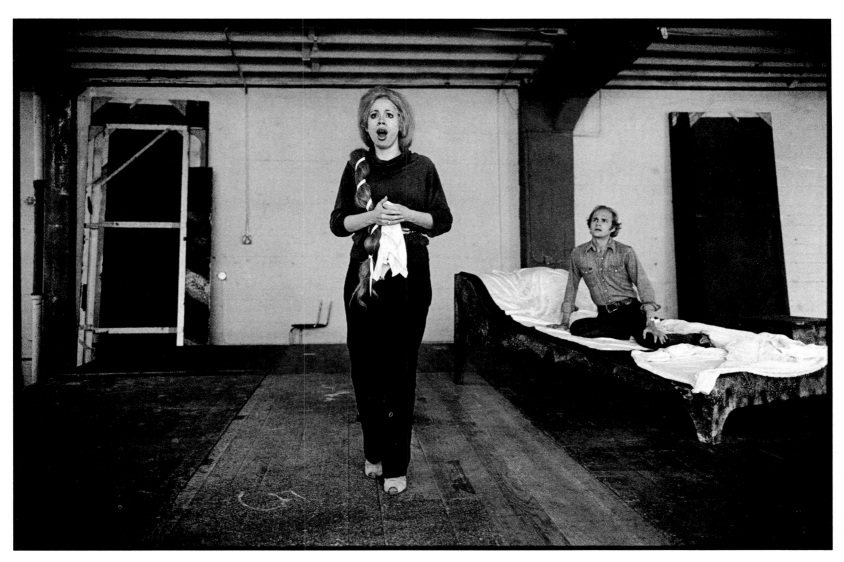

In a low-ceilinged rehearsal hall, mezzo-soprano Maria Ewing, as Mélisande, and baritone Michael Devlin, playing Golaud, rehearse a scene from *Pelléas et Mélisande*. She is wearing the wig (made partly of real hair and partly of synthetic fibers) that plays a crucial part in the plot. Other than the singers and the wig, little from this 1979 rehearsal would have been recognizable onstage in the production, which was a romantic fantasy of shifting lights projected on scrims and nets.

Once the principals have learned where they will be onstage, the chorus is called in. The chorus is the infantry of opera—essential, anonymous, and used to being ordered around. Its members are chosen for their vocal talents and stage presence, but they survive through sheer endurance.

On a typical day during the season, a chorister rehearses all afternoon, takes a break for an early dinner, and is back at the opera house by seven to be dressed and made up for a performance that will end close to midnight. In a typical week, choristers rehearse and perform as many as six operas, sing in three or four languages, and play the roles of peasants, soldiers, ladies-in-waiting, noblemen, priests, and townspeople, sometimes changing roles, costumes, and makeup several times during a single opera.

Besides singing, the chorus members are expected to march, dance, carouse, react dramatically to events, and generally contribute animation and excitement. When they're not rehearsing or performing they are memorizing, cramming in the music and words for about fifteen operas a year. They work at this pace from mid-April, when rehearsals begin for the summer season, through mid-December, when the curtain descends on the last opera of the fall season. It is an all-consuming schedule that can wreak havoc with normal family life.

Choristers become neither rich nor famous for their efforts. For all the hours that the chorus spends onstage, even the most devoted opera fans do not know the members by name and most likely would not recognize them out of costume. The wife of one veteran chorister swears she can pick his voice out of the ensemble but cannot pick his face out of the crowd.

For some, the anonymity is frustrating. They dream of getting out of the crowd and into the ranks of the solo singers. Others are perfectly happy to be part of the chorus, considering it an ideal way to be part of the opera without the tension and responsibility of singing solo. For them, the fact of making a living in music is miracle enough.

"Every time I think of working in that bank, I can hardly believe how lucky I am to be doing this," said one of the many who have given up more lucrative, more secure jobs to sing in the chorus.

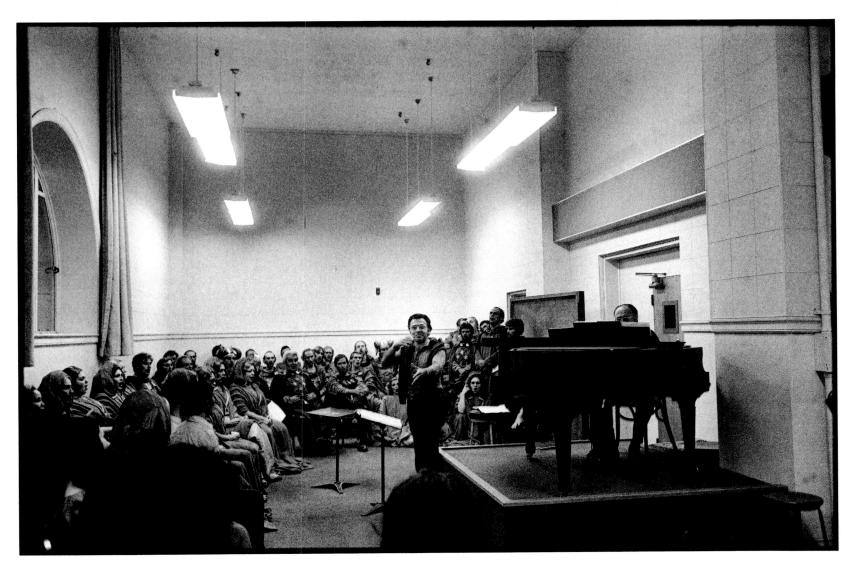

The chorus, already in cos-
tume for a dress rehearsal of
Norma, goes through a last-
minute run-through with
conductor Paolo Peloso.

Downstairs in the opera house, the chorus's communal dressing rooms are cozy and cluttered. Members bring pictures, photographs, even wallpaper to decorate their individual spaces. When they are not onstage, the choristers are busy knitting, mending, studying their music, talking, celebrating birthdays, and playing the endless poker game that lasts from the beginning of the season to the end.

The chorus is a family in which there is both closeness and competition. Although some members are happiest when they are left to stand in one place and sing, others hope to be chosen for the bits of individualized acting and solo singing that are occasionally available. Besides offering a chance to break out of the pack, extra acting and singing mean a little more money for each performance.

THE SPEAR CARRIERS

The last group to be put into place during the staging rehearsals is the supernumeraries, opera's answer to Cecil B. De Mille's hordes of extras. Opera is spectacle, and the spectacle often depends on sheer numbers of elaborately costumed people filling the stage. When soloists and chorus are not enough, supers are called in to carry spears, march in platoons, mill around, kneel reverently, applaud enthusiastically, and just fill up space—all without singing a note.

Director Lotfi Mansouri explains, "Sometimes when the chorus is very musically involved, it limits the amount of motion they can do. They have to watch the conductor. So you secure musical solidity through the chorus and use supers for the action."

In one scene in a recent production of *Il Trovatore*, the chorus men, playing the Count di Luna's soldiers, were planted firmly in platoons. While they sang, supers marched enthusiastically in the background, carrying spears and waving banners.

In director Jean-Pierre Ponnelle's rich and lively crowd scenes, each super is given a distinctive appearance and specific actions.

Occasionally a super gets to play one of the handful of operatic roles that require neither singing nor speaking, such as the Countess d'Aremberg in *Don Carlos*, but generally supers are used en masse.

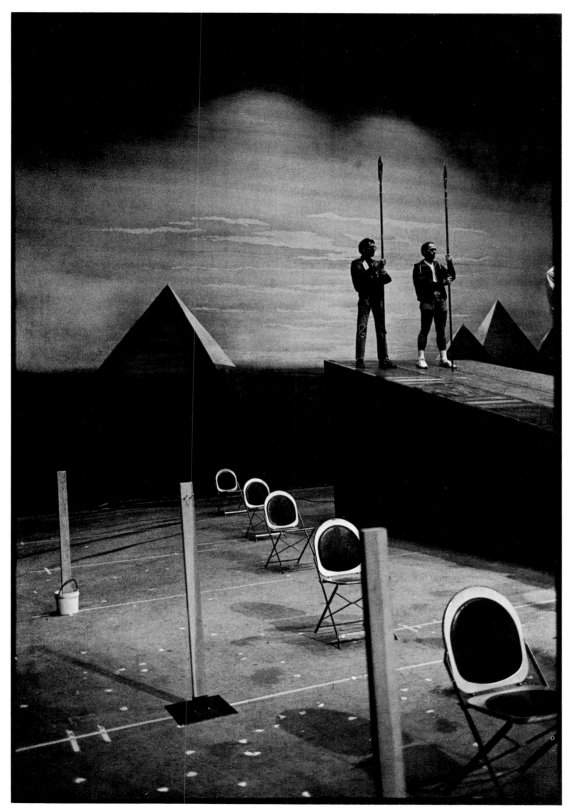

With chairs to represent columns and poles embedded in concrete-filled buckets to represent the wings, spear-carrying supers rehearse their roles in *Aida*'s grand march.

When hopeful supers are called in for tryouts a couple of months before rehearsals begin, the atmosphere is more police lineup than theatrical audition. Appearance and a reputation for showing up on time count more than acting ability. In particular, tall men are always in demand to play opera's countless guards and soldiers.

Although many supers are avid music lovers, musical ability is not a requirement. As inexperienced directors have learned to their sorrow, it is a mistake to expect supers to raise their swords in time during the grand march in *Aida* or to do anything on a certain note.

Once rehearsals start, supers are ordered around namelessly. When performances are scheduled, they have to arrive two hours before curtain time, so that they can be made up and dressed before the chorus and principals arrive. During the opera, they are supposed to stay downstairs in their dressing rooms when they are not onstage. For all this, they are paid a nominal two dollars per rehearsal, five dollars a performance.

Nevertheless, the opera never has any trouble finding supers. In San Francisco, lawyers, doctors, hairdressers, housewives, and policemen are among the people who hear about the openings by word of mouth, volunteer for the work, and keep coming back year after year. For many of them, it is a way to see more opera than they can possibly afford and to get to know the music intimately. Some revel in the proximity to superstars, while others love the smell of the greasepaint and the roar of the crowd. They delight in being transformed by heavy makeup and elaborate period costumes, even if it is only for a thirty-second appearance in the background of a crowd scene.

A SILENT MOVIE

For all the offstage and onstage drama of staging rehearsals, the total effect is sometimes closer to silent movie than grand opera. The rudimentary sets are only a hint of what will be on stage during the performance. A plastic vase serves as a chalice, a stick is the hero's sword, a jumble of boards and wire represents the sacred fire. Instead of an orchestra's expansive sound, there is a single piano. Many of the singers are singing at half volume.

The cast is wearing typical rehearsal costumes. For men, that is often blue jeans with swords tucked into the belt loops. A

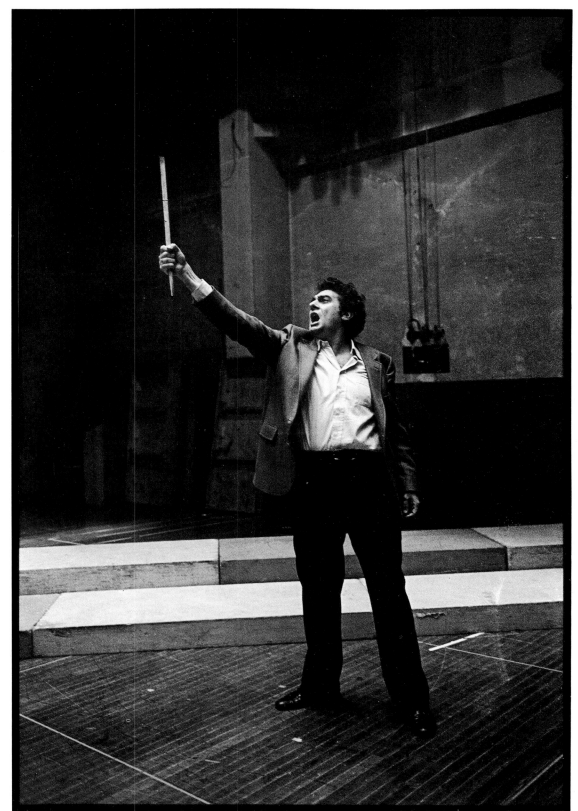

Tenor Placido Domingo
may be holding a stick
instead of a sword, but the
magic of this dramatic
moment in *Samson et Dalila*
is undiminished.

heap of shabby underskirts is available for women who want to get the feeling of period costumes.

One day, the principals are reacting melodramatically to nonexistent crowds of choristers and supers, who are represented by a single assistant director or production assistant rushing about the stage. The next day, the chorus will be reacting to imaginary principals, whose parts are being sung by the prompter. The total effect is sometimes hilarious. Singers, for all the intense concentration they bring, are often the first to laugh at the incongruity of it all, giggling as they rehearse some of opera's more farfetched turns of plot, sighing resignedly as they lie down to play dead on a dusty floor.

THE DANCERS

If the opera has a ballet sequence, the dancers begin to rehearse about two weeks before opening night, starting in the ballet room and then joining the staging rehearsals. Dancers need a special flexibility to become members of an opera's ballet corps. The members of the corps must be versatile, ready to dance everything from a sixteenth-century court dance to a folk dance, working *en pointe* in one opera, barefoot in another. Acting ability and a visible stage personality are as important as technical ability, because opera directors often ask dancers to melt into the crowd, performing as actors until it comes time to dance. Acrobatic skill is a useful asset as well, to add life to opera's parades, parties, and fairs.

The dancing conditions are often far from ideal. The stage may be crowded with chorus and supers, with only a little patch of space allotted for the dance. The floor may be covered with a rough surface, such as cobblestones, or with a painted canvas. Steps may stretch the whole width of the stage, or the stage may be raked, slanting upward from front to back, so that each turn has an element of danger. Costume designers, some of whom may never have designed specifically for dancers, sometimes add to the dancers' challenge, limiting their movements with long dresses and heavy wigs.

For all the problems, as well as the indisputable fact that ballet has become a rather small part of the operatic whole, the opera dancers do perform in circumstances that most dance companies cannot afford. Although the performance is brief,

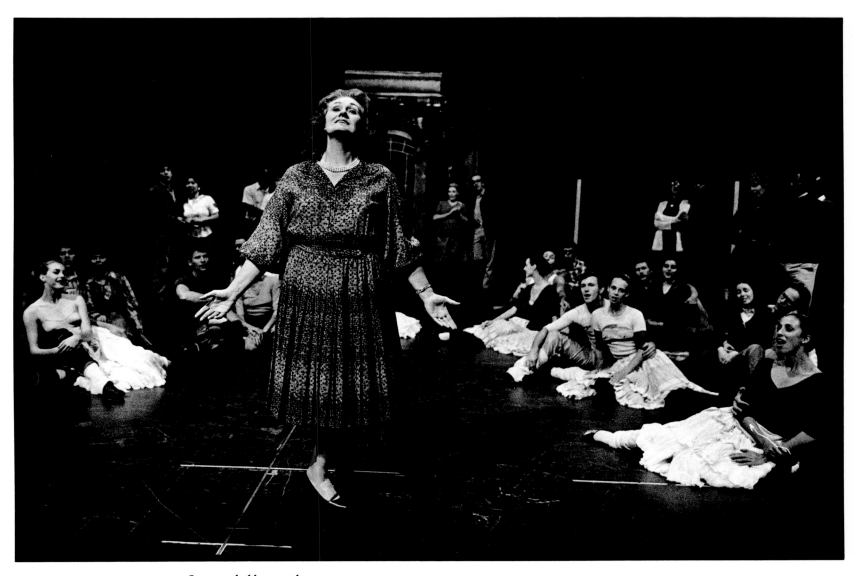

Surrounded by members
of the ballet corps, Joan
Sutherland gives her all to
a rehearsal of *The Merry
Widow.*

the full orchestra, the lavish costumes, and the intensity of the theatrical experience make opera dancing spectacular.

THE CONDUCTOR AND THE ORCHESTRA

In contrast to the milling crowds and free-floating anxieties of staging rehearsals, the orchestra's rehearsals are apt to seem like peaceful interludes in the process of opera making. The conductor is at the podium, the musicians are in the pit, and the only other person probably in attendance is the assistant conductor, sitting in the front row of the darkened opera house.

A polite formality generally governs the relationship between the orchestra and its leader. Every conductor, no matter what his age and experience or his friendly ties to the players, and regardless of whether he is conducting the whole orchestra or one offstage triangle player, is addressed by the respectful title "Maestro" during rehearsals. In turn, the players expect to be treated with respect and will file an official complaint with union and management if they are not.

Some of the greatest conductors in the world have failed when they tried their hand at conducting opera, lacking either the personality or the flexibility to thrive in the give and take that must exist between singer and conductor, stage and pit.

At the same time that the conductor is being adaptable, he also has to be sufficiently strong-minded and persuasive to give the production a musical flow and cohesion. He, at least as much as the director and the set designer, sets the mood of the production. The wittiest *Don Pasquale* and the most charming *Barber of Seville* will be ruined by a heavy hand in the pit, and a Wagner work will seem interminable if no sense of power and intensity enlivens the music.

A symphony conductor expects to arrive at rehearsals, make his ideas clear to the musicians, and then hear them play the same way at each performance. But opera is not conducive to this kind of authoritarian approach. Instead of being clearly in command, the conductor must work in a cooperative effort with the singers, who have their own ideas about tempo, volume, and phrasing. Some singers may be willing to adapt, some do not want to even consider it, and a few mean to make changes, do so in rehearsals, and then forget them once the performance has begun.

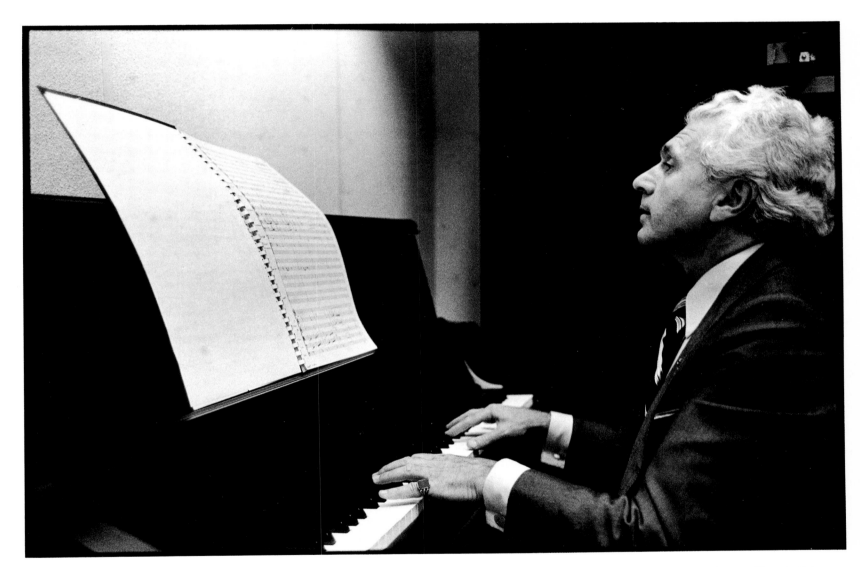

Julius Rudel, former director of the New York City Opera, has specialized in French opera in San Francisco, conducting Debussy's *Pelléas et Mélisande*, Saint-Saëns's *Samson et Dalila*, and Massenet's *Manon*. Here he plays a part of the score of *Pelléas et Mélisande*.

Each singer's capabilities are different. A conductor may have done *Lucia di Lammermoor* fifty times, but each new Lucia will require something a bit different from the orchestra—softer here for a light voice, faster there to help another voice glide through a difficult moment.

The greatest asset an operatic conductor can have is an understanding of the human voice. Many of the conductors happiest in opera worked their way up through the ranks as musical coaches, rehearsal pianists, and assistant conductors, always working in close contact with singers.

Experienced opera orchestra players share this sensitivity to the human voice. Zaven Melikian, concertmaster of the San Francisco Opera Orchestra, says that he can listen to a singer take a breath and know exactly when the performer will attack, how he will sound, and how long he will hold the note.

Although the musicians in the pit do not have a clear view of what is happening just behind them on the stage, they are sensitive to the slightest variation in the performance. Tonight, the tenor enters a second late or a door gets stuck, and the orchestra pauses for a moment. Tomorrow, a singer may be in particularly good voice and want to hold the perfect notes a second or two longer, and the orchestra must not rush ahead. The next night, a soprano far upstage, forty feet from the conductor, is off pitch or losing the tempo; the orchestra may play a few bars fortissimo to get her back on the track. An experienced opera orchestra does these things almost automatically, sometimes without needing a signal from the conductor.

Opera musicians also need special flexibility to deal with a stream of guest conductors, each with his own ideas about the opera at hand and the rapport between stage and pit.

Opera musicians have to learn a prodigious amount of music each year, and although they work long hours during the season, they labor less visibly and seem to get less credit for their efforts than symphony players. Nevertheless, they speak enthusiastically about the excitement of being part of a theatrical experience.

A conductor was saying goodbye to a friend who was leaving the opera to join a symphony. "Think," he said, "plenty of rehearsal time, no more singers spitting into the pit, and plenty of real music, Bartók and Beethoven, instead of stuff like *Andrea Chénier.*"

"That's true," said the departing musician. "But on the great nights, there's nothing like it."

Soprano Birgit Nilsson and Kurt Herbert Adler, long-time general director of the San Francisco Opera, are old friends. She made her American debut in San Francisco in 1956, singing Brünnhilde in *Die Walküre*, and has returned many times since. Here she brings all her emotional intensity to a rehearsal with Adler and pianist Philip Highfill for a 1979 concert appearance.

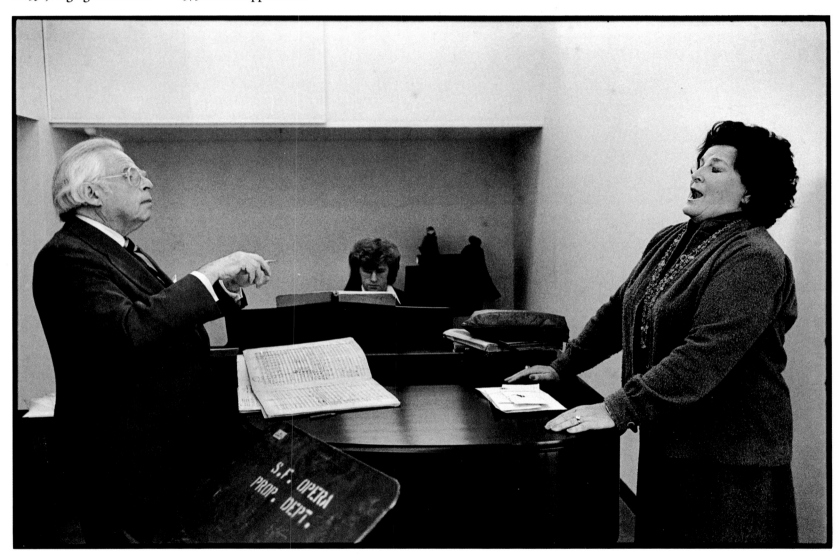

FROM *SITZPROBE*
TO OCA+

The first contact between singers and orchestra comes about halfway through the rehearsal period, at a session usually referred to by its traditional German name, the *Sitzprobe*. The emphasis in this rehearsal is purely on the music, with no theatrical trappings of staging, sets, or costumes. The musicians, many in shirt sleeves, are in the pit, and the soloists are sitting on folding chairs that have been set up in front of the lowered curtain. They perform the score right through, skipping the chorus parts, to let orchestra and singers get used to each other.

The visual embellishments are put into place during the week before opening night at the piano dress rehearsal, or the PCA+. With its piano, chorus, artists, and with the big plus of the actual stage, the sets, lights, costumes, and makeup, the casual intimacy developed in the rehearsal hall is gone. The cast is fragmented into dressing rooms on three floors of the opera house. The choicest dressing rooms, usually reserved for the leading soprano, mezzo-soprano, and tenor, are on stage level;

When rehearsals are held onstage with the sets in place, yet the performers are wearing their own clothes, the effect is often incongruous, but Leonie Rysanek looks right at home in the sumptuous setting for *Der Rosenkavalier*. Like most opera sets, this one features a painted canvas on the floor, probably the most important aspect of the set for the people looking down from the highest seats in the house.

Carol Neblett puts the final touches on her makeup as she prepares to sing the role of Minnie in *La Fanciulla del West*.

Tenor Luciano Pavarotti is among those operatic superstars who like to put on at least part of their own makeup. Here, with make-up artist Leslie Sherman looking on, he adjusts his wig before a dress rehearsal of *La Gioconda* in 1979.

burlap imitating velvet. Now velvet is velvet and brocade is the real thing. Considerable effort is given to making the costumes historically correct. The plot of *Il Trovatore* may be farfetched, but the swords wielded by Manrico and the Count di Luna will be as authentically fifteenth century as possible. Moreover, all performers, from superstars to supernumeraries, are forbidden to appear onstage wearing such modern accoutrements as wristwatches, glasses, and nail polish.

Realism has also brought more individualism in costuming. Each Meistersinger has his unique costume. Even in crowd scenes, the populace of chorus and supers is dressed to present a variety of people, rich and poor, sober and garish. In the *La Gioconda* staged by the San Francisco Opera, one of the most elaborate productions ever seen there, each of the 120 performers who filled the stage had a different costume.

In preliminary budgeting, each male principal's costume is estimated to cost about $1,000, and each female principal's attire is two to three times that. Some extremely elaborate costumes, such as Pavarotti's brocade tunics in *La Gioconda* and Joan Sutherland's ruffled confections in *The Merry Widow*, cost upwards of $5,000 apiece.

Even peasant costumes are expensive. A full-sleeved peasant shirt costs $400, a ruffled petticoat, $200. Fortunately, peasant dress does not change much from century to century, so the same petticoats, skirts, blouses, trousers, and vests are endlessly recombined, restyled, and redyed, season after season. When they finally fall into rags, they become costumes for opera's many beggars.

The costumers may have to strike a balance between the designer's wish for historical accuracy and dramatic effect and the singers' wishes to be attractive onstage. The superstars know exactly what is flattering to them and are quick to point out a silhouette or a detail they do not like. The historically accurate silhouette may be changed if a star finds it unflattering.

The costume shop has some magic tricks of its own. Costumes are sometimes sprayed a slightly darker color along the sides, which gives a slimming effect. The atmosphere of the production is sometimes emphasized by giving all the costumes a quick bath in dye so that they take on a similar cast. For a recent production of *Carmen,* the cigarette girls' dresses were dipped in black to give the colors a muted, grayish cast.

Singers, particularly sopranos scheduled to die tragically onstage, often request knee pads to make their final, anguished falls a bit less painful. One leading Wagnerian singer ties foam-

Dresser Jack Cook makes a final adjustment on the elaborate, stylized costume worn by baritone Wolfgang Brendel for his role as the High Priest in *Samson et Dalila*.

Tenor Richard Lewis, dressed for one of his most famed roles, Captain Vere in Britten's *Billy Budd*, gets a last-minute adjustment from dresser Joseph Harris.

rubber falsies around her knees with elastic bandages just before going onstage.

Onstage at the piano dress rehearsal, the costumes and makeup are having a dramatic effect. The shortest and squattest of the choristers suddenly looks vaguely heroic in Renaissance velvet, and the supers who have been slouching around in blue jeans walk with grace, inspired by their period costumes. Crowd scenes that seemed like pandemonium in the rehearsal hall now have form, as sweeps of color take shape on stage. Lights and sets are working their magic, too. Now castle walls take the place of strips of tape on the floor, and flickering candles replace sticks.

Despite the transformation, however, the presentation at the piano dress rehearsal is still far from a finished product. Onstage, lights are flickering on and off like summer lightning, midafternoon is suddenly midnight, and singers are left in total darkness. Months before, when the lighting plan was first rehearsed, the director may not have known exactly where the tenor would be standing for his big aria. Now the lighting designer, back at his long desk in row M, is adjusting cues and adding lights that focus on the singers. That many singers do not bother to sing out at this rehearsal is hardly surprising, since the emphasis is on technical, not musical, problems. The music is punctuated by the click of camera shutters. Staff photographers have set up their tripods in the front row to take the pictures that will appear in the centerfold of the program.

Only a few dozen people sit in the darkened house; but from the general director on down they are all acting as critics, and most of them are busily taking notes. A superstar hates her costume so much that she suddenly appears in her own skirt and sweater to sing the second act. A tenor wants an additional costume. The chorus women's gloves are the wrong color. The chorus men's tights are too light, making their legs look embarrassingly bare. One performer's wig is of the wrong period for the opera, and another's makeup is too light. Mustaches are askew. A camp fire looks too new.

Tempers flare, the director rushes out onto the stage to rearrange a group of people, singers fumble with props, and it is hard to believe that this is an opera that will open in less than a week. In fact, incredible changes are still possible. In the next few days, the costume shop will create new costumes for the stars, dye the offending gloves, and spray the chorus men's tights a less revealing shade. The wigs will be restyled, a darker makeup scheme will be planned, and the mustaches will be firmly attached. The camp fires will be aged instantly with the

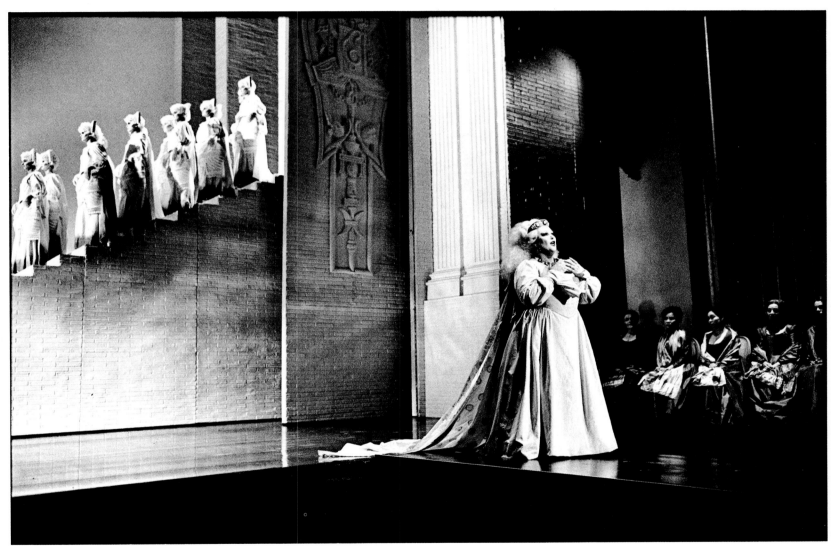

Italian designer Pier Luigi
Pizzi's 1981 stylized setting
for Rossini's *Semiramide* was
one of the most contro-
versial of the season.
Montserrat Caballé moved
out toward the audience on
a runway built over the
orchestra pit. Part of the
chorus acted as observers,
sitting at the edges of the
proscenium, while others
posed still as statues upstage
on steps built of white
plastic bricks.

addition of torn gray rags. Sets can still be touched up and props changed. The lighting will be reworked, and the final cues will be fed into the computer.

THE FINAL REHEARSALS

Another important rehearsal takes place in the week before opening night. This one is known as the OCA, the rehearsal department's code for orchestra, chorus, and artists. It takes place on the stage, with the sets in place, but the stage is usually not lit, and the singers are wearing their own clothes.

Visually, the OCA is far less exciting than the piano dress rehearsal, but this is the first time that all the musical elements of the opera are together—chorus as well as orchestra and soloists. This is the conductor's rehearsal, with the emphasis strictly on musical matters.

Two or three days before opening night comes the orchestra dress rehearsal. For the first time, all the pieces of this massive visual and vocal collage are in place. Even a small invited audience appears—friends, donors, extra chorus members—sitting up in the dress circle. Members of the staff wander in to sit in the side sections of the orchestra, or they lean over the half-wall at the back, where the standees usually are.

The final dress rehearsal is supposed to be as much like a performance as possible, a run-through of the entire opera without interruption. In fact, disasters still occur. Sets wobble, props disappear, people run into each other, lights fail to catch up with singers, bits of stage business do not work, and arguments explode between stage, pit, and the center aisle, where the director is pacing up and down. Afterward, everyone assures each other that a bad dress rehearsal means a good opening night. The stage director and conductor have a few last notes for everyone, and the hectic rehearsal period is over.

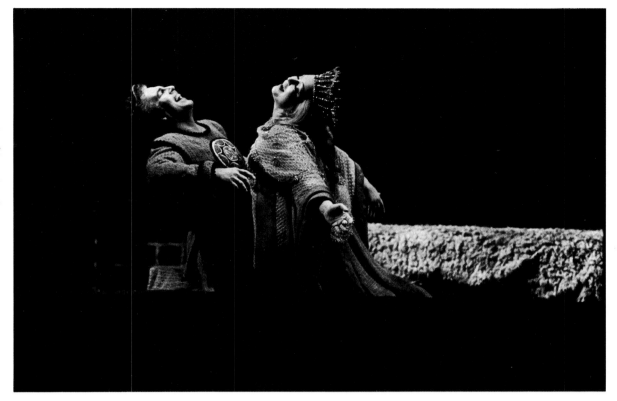

This photograph of Spas Wenkoff and Gwyneth Jones during a dress rehearsal of *Tristan und Isolde* sums up the emotional drama of opera. Even with interruptions and disasters, the final dress rehearsal may have all the intensity of a performance.

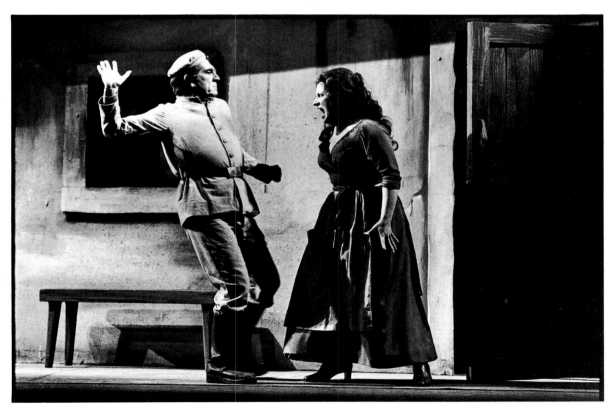

During the final rehearsal for *Wozzeck*, Geraint Evans, who both directed and starred in this production, has raised his hand to slap Janis Martin, playing Marie.

Shirley Verrett, wearing a loose robe and turban, waits in her dressing room for the makeup artist and costume department to transform her into Norma.

Ingvar Wixell undergoes transformation in the hour before the curtain rises on a performance of *Arabella*.

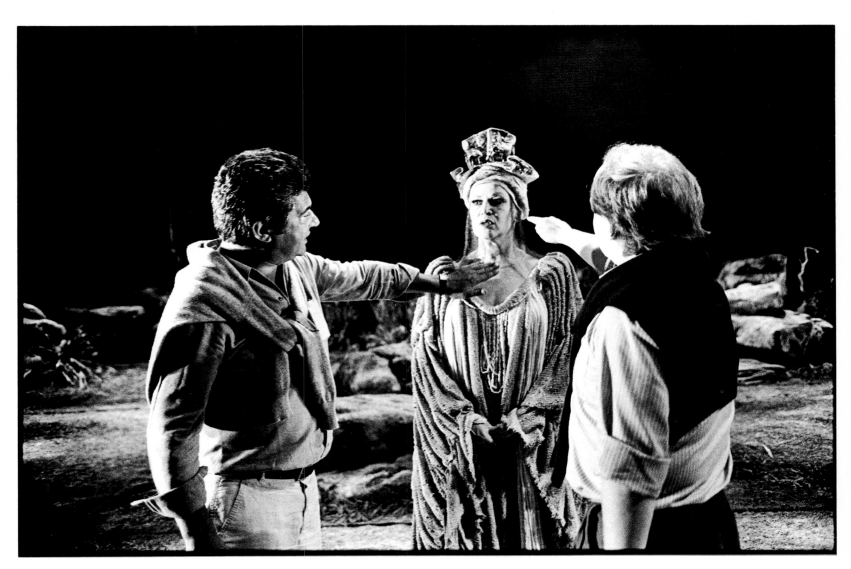

Director Jean-Pierre Ponnelle and costume designer Pet Halmen discuss coloratura soprano Rita Shane's costume during the piano dress rehearsal of *Lear*. The piano dress rehearsal is the first time that the performers wear their wigs, costumes, and makeup. In the few days remaining before opening night, there are always corrections to be made.

Tenor Placido Domingo casts a long shadow during a dress rehearsal of *Otello* in 1978.

Shirley Verrett, surrounded by members of the chorus, and Placido Domingo share a dramatic moment during the final dress rehearsal of a 1980 production of *Samson et Dalila*.

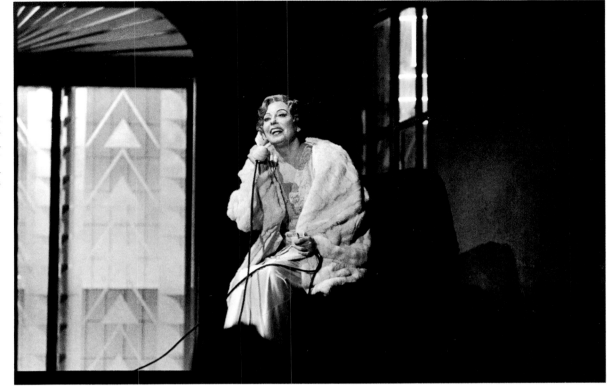

Compared to most operas, Pet Halmen's art deco set for Poulenc's *La Voix Humaine*, a forty-four-minute solo that starred Magda Olivero in a 1979 production, seems fresh and modern.

Marilyn Horne's brilliant red brocade cape was one of the few notes of color in Pier Luigi Pizzi's all-white design for *Semiramide*.

Magda Olivero, a soprano famed for one of the longest careers in operatic history, is transformed in this series of photographs into the heroine of Francis Poulenc's *La Voix Humaine* by wigmaster Richard Stead. Her own hair is pulled back tightly into a hairnet, makeup is applied, and the wig is glued carefully into place. Changing perfectly ordinary-looking people into dramatic personages is routine for opera's wig and makeup artisans.

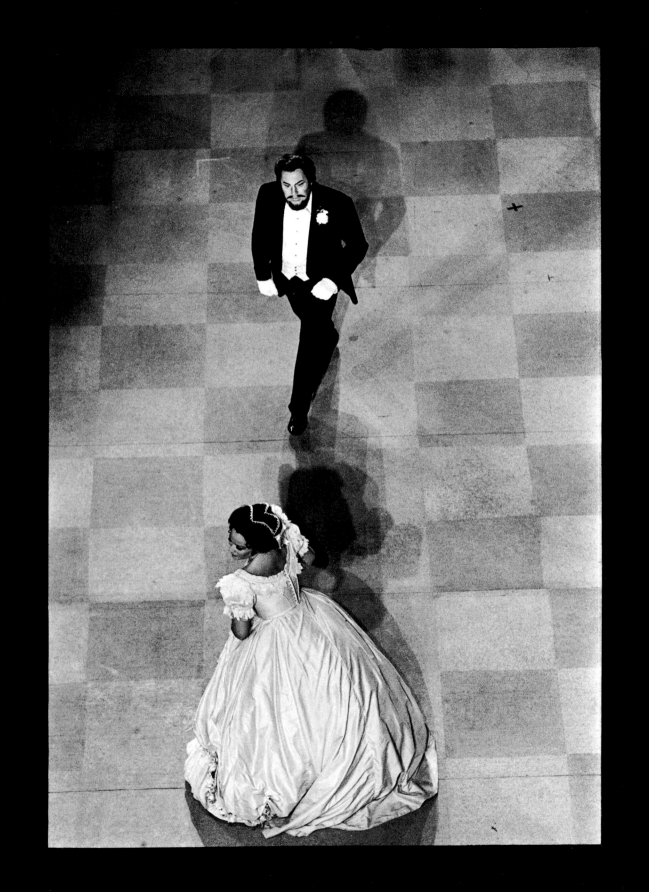

PERFORMANCE

During rehearsals, opera singers play at being ordinary people. When the day of a performance comes, they retreat into a world of their own. It is usually a silent world. Many singers prefer not to speak on the days they perform; talking, they explain, takes the bloom off the voice.

The Voice. Singers do not talk possessively about "my voice." It is always "the voice," as if it were a creature apart, a living thing whose behavior can be influenced but never completely controlled. It never responds exactly the same way. Fatigue, climate, and health affect it. So does an upsetting letter from home or an argument with a friend. Even when the voice is healthy, it feels a little different each day, and singers adjust their technique accordingly.

Some singers put off the moment of truth until an hour or two before the curtain goes up, but others start testing the voice much earlier.

"I sleep well on the night before a performance, but the moment I wake up the first thing I do is wonder whether I have the voice," mezzo-soprano Teresa Berganza explains. "I start testing even before I get out of bed. Then I go into the bathroom so that I can sing in the shower, to make sure that the voice is really there."

For most singers, the day of a performance is hours of nervous tension controlled by compulsive ritual and routine. One singer insists on eating a meal a precise number of hours before

she sings her first note; others always eat the same meal. Some like to get to the theater as early as possible. Their official make-up calls are usually an hour before their first stage appearance, but some performers arrive as much as two hours earlier, taking comfort in the bustle of dressers, makeup artists, and the prompter arriving with a few last notes. Other performers, to the dismay of the wardrobe and makeup departments, rush in at the last minute, like racehorses into the gate.

Stage fright, the performer's particular malady, clutches at operatic superstars as well as at the youngest comprimario singers. The superstars, caught up in a publicity phenomenon that leads audiences to resent the slightest failure, may suffer the most of all in the hours before they walk out onto the stage. Some get down on their knees and pray in their dressing rooms, some wear lucky charms under their costumes, some do exercises, and others perform rituals that they keep ritualistically secret. Once dressed and made up, they sit at the piano in their dressing rooms, vocalizing to warm up or running through the difficult passages. The general director makes a ritual of going to each dressing room with a final embrace and a good luck wish. In opera, as in the theater, it is not good form to say "good luck" to a performer. The traditional "break a leg" is fine. Even better is the opera world's special wish, *"In bocca al lupo"*—into the mouth of the wolf—to which the ritual reply is *"crepi il lupo"*— may the wolf die. Less poetic but equally popular is *"toi, toi, toi,"* a traditional good luck wish in German and Austrian opera houses.

Opening night has its own special mood that is part nervous, part festive. All day, the rehearsal department receives flowers and letters for the singers. Bottles of champagne are cooling in buckets. For most productions, this is the only performance the director will see. The next day he leaves for another opera house, but tonight he is backstage, giving a few final notes and embraces to the singers, fretting over details, and generally adding to the tension.

The worst time of all is the few minutes in the wings just before going onstage, when nothing is left to do but pace silently or chatter nervously to the stage manager or, as Placido Domingo does, make one final sign of the cross.

Bass Kevin Langan says, "It's the same nervous routine every time. You're standing there with sweaty palms and butterflies in the stomach and you say, 'I can't go on, what am I doing in this business, I'm going to have a heart attack or an ulcer. Do I have a voice? Am I going to have the top notes? Is the audience going to like me?'

Conductor Reynald Giovaninetti and stage director Nicolas Joël flank soprano Magda Olivero on the opening night of *La Voix Humaine*.

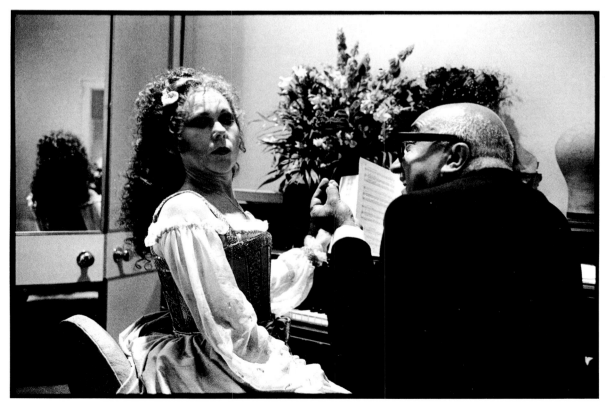

On opening night, the director is still in town; the next day he will be off to another city, another opera. On the opening night of *La Gioconda*, director Lotfi Mansouri gives some last-minute words of encouragement to Renata Scotto.

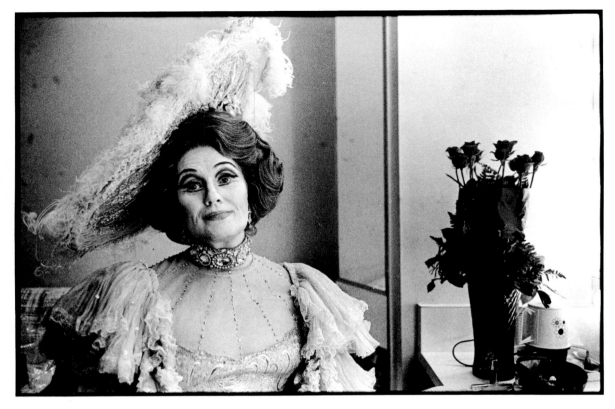

Opening night means flowers in the dressing rooms and even more tension than usual. Joan Sutherland, costumed and made up for *The Merry Widow*, waits during the final few minutes before the curtain.

"And then you get that initial sound out and you say, 'ahh, it's there,' and away you go."

Singers talk about getting a role into the voice, an alchemy that takes place only in the crucible of a performance. In spite of the weeks of rehearsal and the hours spent with vocal coaches, only the performance proves to them that the role is under control. When a singer has dealt with action, sets, lights, heavy costumes, the acoustics of the house, and a dozen other distractions and still gotten through the dreaded difficult parts, then he begins to feel confident. Total assurance will only come after a few more performances.

In the few minutes before the curtain rises, no one backstage really knows what kind of performance it will be. Even after countless rehearsals, it is impossible to predict when a performance will suddenly explode with that fusion of technical excellence and electrifying energy that keeps audiences breathless in their seats. This kind of theatrical ecstasy happens without warning. Suddenly the voices are right, the timing is perfect, the acting is effective, and there is a rapport between conductor and singers. Everything succeeds—not just for one person but for the entire cast.

Wagnerian soprano Birgit
Nilsson poses in her dressing
room before a 1979 concert
appearance.

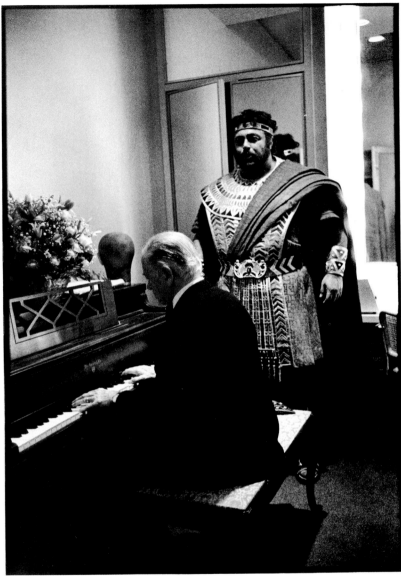

Just before his first appear-
ance as Radamès on the
opening night of *Aida*,
Luciano Pavarotti practices
in his flower-bedecked
dressing room with Maestro
Antonio Tonini, master
coach of La Scala, at
the piano.

Considering the number of people involved in opera, it is a miracle that these magical, soaring performances ever happen. Optimists talk hopefully of it occurring once or twice in ten performances, pessimists speak cautiously of it happening once or twice in a singer's career, and everyone agrees that it is totally unpredictable. Great voices are not enough, although some superstars, through their intensity and concentration, can inspire a whole cast. The rapport that develops during rehearsals may play a part. Singers who loathe each other can go through the motions without the audience suspecting that their embrace is filled with contempt, but even so, manufactured ardor rarely produces a soaring performance.

Last-minute substitutions often result in memorable operatic thrills. While the audience nervously wonders what the turn of events will produce, the whole cast is galvanized into a special effort to help the newcomer.

BEHIND THE SCENES

Curiously, backstage is not a good place to appreciate the incandescent theatrical moment. From the wings, one's view is certainly intimate, if odd – the tenor scratching his nose during an embrace, the chorister struggling to suppress a cough or a giggle – but the emotional intensity of the performance, like the music, is directed outward, into the audience.

Once the curtain rises, the opera house is divided into three distinct worlds. Out there the audience is lined up neatly, row upon row into the darkness of the upper balcony seats. And here is the stage, a bright rectangle inhabited only by the performers. Finally, there is backstage, the shadowy vastness hidden behind the sets.

At first glance, backstage seems chaotic. If the sets were suddenly to fly upward, the audience would see dozens of people going about their business just a few feet from the performers. In the wings stands a crowd of production assistants, staff members, principals waiting to go on, assistant conductors, chorus directors, electricians, prop men, stagehands, and the occasional bold choristers and supernumeraries who have broken the rule that restricts them to their downstairs dressing rooms when they are not performing. Farther back, stagehands are taking catnaps in the shadows, slouched against a conven-

Kurt Herbert Adler, dressed and bemedalled for opening night, makes a last-minute tour through the wig and makeup rooms downstairs in the opera house just before the curtain of *Samson et Dalila*, while makeup artist Richard Battle pulls back a performer's hair into a tight hairnet.

Orchestra members sometimes seek out quiet corners so that they can spend the intermission practicing. Here, John Bischof warms up on the trombone during *Lohengrin*.

ient pile of plastic rocks or stretched out in the compartments formed by the framework of the sets. In a small room just off stage left, the prop men are watching a football game on television, only a few yards above the heads of the audience.

Everyone is milling around in a darkness punctuated only by the bright glare of television screens, all showing a close-up view of the conductor in the pit.

Signs state "no talking," but backstage is a surprisingly noisy place during a performance. Protected by the invisible curtain of vocal and orchestral music, people chat quietly as they wait in the wings. The audience rarely hears any of the backstage chatter, but singers occasionally do; when Luciano Pavarotti, singing Radamès, heard stagehands talking during the tomb scene in *Aida*, he marched to the side of the stage to tell them to be quiet.

Only rarely does everyone in the wings concentrate on the stage. Occasionally, as when Placido Domingo sings the "Flower Song" in *Carmen*, the whispering stops and there is silent concentration on all sides.

The seemingly random ebb and flow of people backstage does have a pattern. The sound of the performance is everywhere, piped into every dressing room, office, bathroom, practice room, and hallway, and it acts like a loudly ticking clock. The chorus director, upstairs in his office, hears the end of an aria and comes down to give the chorus a cue. A staff member on duty in the administrative offices hears the first notes of the last act and hurries to finish typing a contract. A production assistant, holding a flashlight on the score, gives a cue to a stagehand to fire a gun. An assistant conductor hears a certain E-flat and goes off to conduct a few bars of offstage music.

Almost every opera includes some music that comes from backstage rather than from the pit or the stage. Some memorable examples are the Celestial Voice in *Don Carlos*, the lute music that announces Manrico's entrance in *Il Trovatore*, and the trumpet that summons Don José back to barracks in *Carmen*. Offstage instrumental music, whether a single flute or an entire brass band, is always referred to as *banda*.

In the audience, the sounds of the unseen musicians elicit no surprise. Nevertheless, making sure that the trumpets sound at exactly the crucial moment is one of the tricky little problems of opera production, requiring a flurry of backstage activity from stagehands, musicians, and assistant conductors. Take, for instance, the offstage trumpets in the second act of *Carmen*. As soon as the curtain rises on Lillas Pastia's tavern, stagehands set up three music stands and a television monitor in the darkness

Mezzo-soprano Teresa Berganza waits alone and seemingly calm for her appearance in the first act of *Carmen*. Singers describe the wait to make a first entrance as a terrifying time, filled with self-doubt, in which they doubt the existence of the voice and wish they were almost anywhere else in the world.

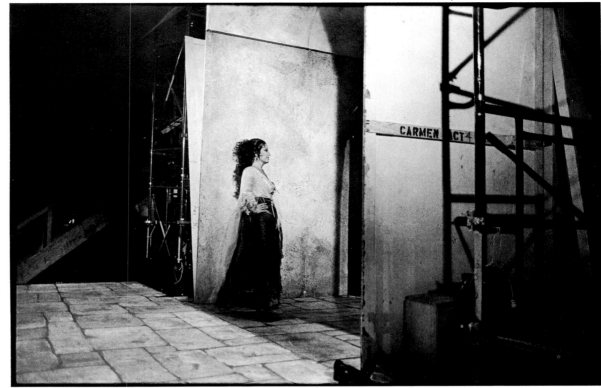

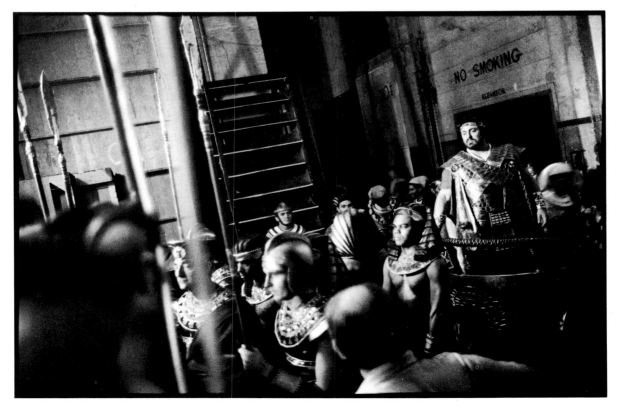

Surrounded by dozens of choristers and supers, Luciano Pavarotti stands in his chariot backstage, waiting for his entrance in *Aida*'s grand march.

just behind the set. Two trumpet players arrive, one an orchestra member who has slipped quietly out of the pit and come upstairs, the other an extra trumpeter hired just for this. The assistant conductor arrives and begins watching the screen, so as to conduct the trumpeters in time with the orchestra. Later in the opera, when the offstage banda includes both the chorus and a brass band cheering Escamillo at the bullring, the musical arrangements are even more complicated. To make sure that the whole crowd gets off on the right note there are two conductors, one for the singers and one for the musicians, each with his own television monitor.

Cumbersome as it is to establish visual contact between the pit conductor and offstage musicians, it is easier than it once was. Before closed-circuit television, backstage performers got their cues from an assistant conductor peering at the orchestra pit through holes slashed more or less discreetly in the scenery.

THE SCENE CHANGES

Five minutes before every major scene change, the mood backstage changes. A red light flashes on overhead, and a five-minute call goes over the public-address system. By the time the singers are beginning the last few bars of music, prop men are standing in the wings with cardboard boxes ready to collect all the small movable objects on the set, carpenters are moving chairs out of the way, and electricians are preparing to lift the sidelights away from the stage. The moment the curtain falls, while the singers are still taking their bows, activity explodes. Until the next set is in place, backstage belongs to the stagehands, and everyone else gets out of the way.

Each group has its own separate backstage life. Staff members, continually wary of last-minute cancellations, go four flights up to the offices to read the messages coming off the telex machines. Conductors and assistant conductors can often be found lounging around the rehearsal department. Principals rush to their dressing rooms, women to the right of the stage and men to the left, followed by a bevy of dressers and makeup men.

Downstairs, the same sex line prevails. Dressing rooms for women chorus members and supers are on the right, male choristers and supers are on the left. Each group of performers stays to itself. The chorus members may be celebrating a birthday.

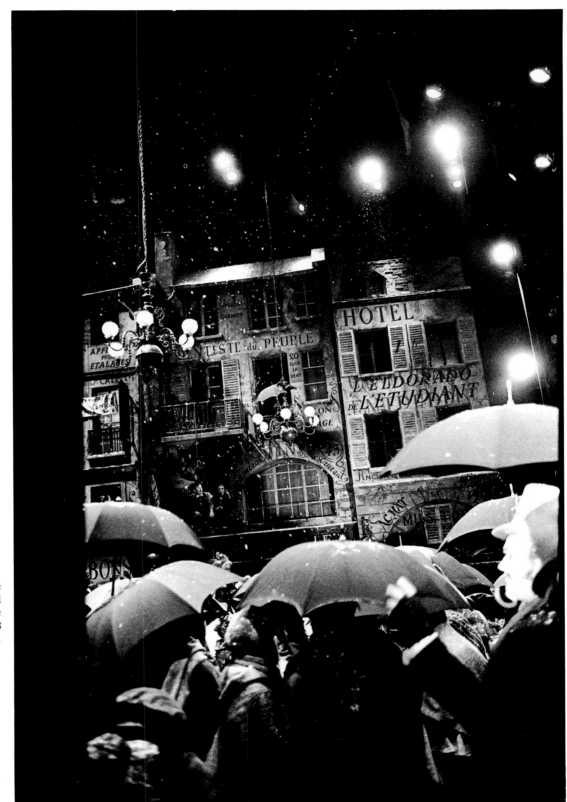

From his desk at stage right, the stage manager had this view of Jean-Pierre Ponnelle's setting for a 1978 production of *La Bohème*.

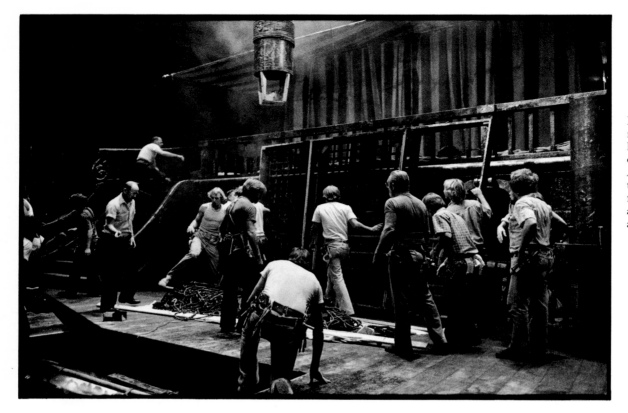

Elaborate scene changes require big crews of stagehands. These are working on a set for the second act of *La Gioconda*, building the ship that goes up in flames at the end of the act—one of opera's most amazing special effects.

The men supers are involved in a raucous card game. Some orchestra members are playing chess and backgammon in their dressing room, while others, hidden away in a dark corner behind a rack of costumes, practice during the whole intermission.

Meanwhile, the stagehands are disassembling mountains, numbered rock by numbered rock, and putting together make-believe buildings like giant Tinker Toys. Sets are rising, and others are descending from the ten-story-high space above the stage. As opera scenery has grown more complicated, the crews needed to manipulate the sets have grown accordingly. Jean-Pierre Ponnelle's recent *Carmen*, featuring a sliding wall and a forty-foot-high mountain of rocks, required a backstage crew of seventy-seven carpenters, electricians, and prop men. *Die Frau ohne Schatten*, a fantasy of moving towers, broke the record with ninety-seven stagehands on duty, some dressed totally in black so that they could work invisibly while the curtain was up.

Once the last nail has been driven and the last props have been put in place, a stagehand walks across the stage spraying a fine mist of water to settle the dust. The final touch is a stagehand's sweeping the floor with a long metal bar attached per-

The forty-foot mast of the ship in *La Gioconda*, though impressive to see manipulated by stagehands, is not quite as heavy as it looks. The mast is made of a giant cardboard tube of a sort usually used in the process of molding concrete and is painted and decorated to look properly Venetian.

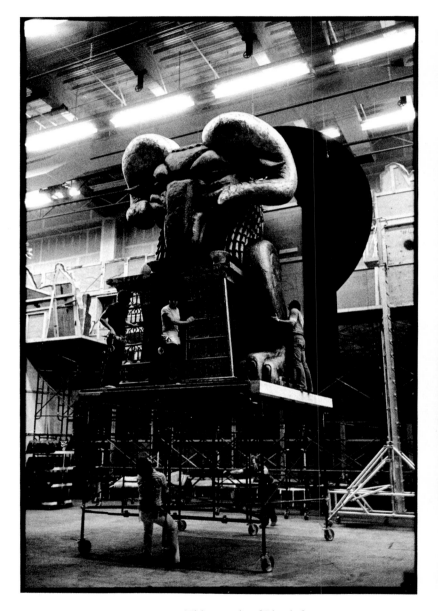

This temple of Phtah for *Aida* is one of the most massive pieces of scenery manipulated by stagehands.

pendicularly to a broom handle. This mysterious gadget is a magnet specifically designed to pick up any stray tacks and nails.

THE STAGE MANAGER

The person in charge of the whole busy backstage scene is the stage manager, sitting on a high stool at a desk just off stage right. Above his head are two television screens: one shows the conductor, the other a view of the stage. On the desk is a score marked with every entrance, lighting cue, and special effect.

The stage manager is the link between the music and the technical aspects of the production. A split second before each lighting change, he or an assistant conductor speaks through his headset to the electrician in the lighting booth. "Cue 6 . . . go"; a button is pushed, and the computers do the rest. The stage manager and production assistants make sure that offstage guns fire, smoke billows, and walls move at the right note.

The stage manager is also responsible for getting the performers onstage at the right time. His five-minute calls — "Miss

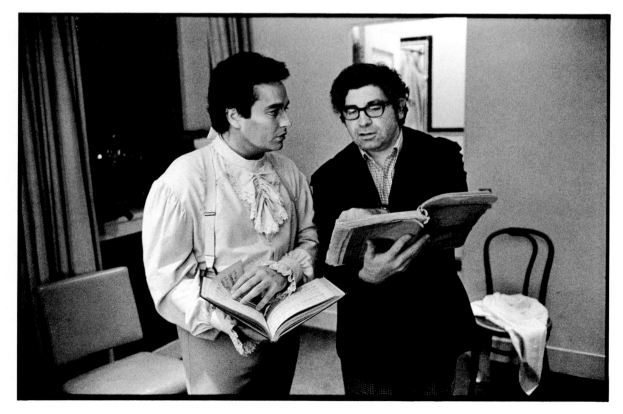

Just before a performance of *Werther*, José Carreras and prompter Philip Eisenberg, scores in hand, discuss exactly how the tenor plans to sing specific phrases.

Offstage during *Carmen* (right), a band of brass players, the chorus, and two conductors—chorus director Richard Bradshaw at left and assistant conductor James Johnson on the right—take their cues from two television monitors focused on conductor Kurt Herbert Adler in the pit. When the audience hears the sounds of the offstage band and chorus in the fourth act (below), this is the scene backstage just behind the wall of the bullring.

Berganza to stage right, ladies and gentlemen of the chorus to stage left, supers to stage left"—are amplified into every dressing room. The courteous tone of the calls is sometimes embellished by stage managers who speak in the appropriate language for each performer. No call is ever omitted, even if the singer called is standing right next to the stage manager's desk, because other people—an assistant conductor, perhaps, practicing the piano in an upstairs coaching room—may be listening for it.

The stage manager is not responsible when a tenor goes out onstage and fails to make the high notes, but he has to explain almost every other mishap that takes place during a performance. If the chorus members fail to sing at the right moment, the stage manager may be asked to explain why the assistant conductor was not around to cue them or why the television monitors showing the pit conductor were not on. If an onstage candelabra flickers incessantly during the mad scene in *Lucia di Lammermoor*, the stage manager must make sure that the electricians fix the problem.

Even in an opera house as highly organized and well-disciplined as San Francisco's, there is plenty of room for the unexpected surprise. Audience and mezzo-soprano alike were startled when a drunk somehow managed to slip by the guards at the stage door and wandered across the stage just as Charlotte was about to launch into the "Letter Aria" in Massenet's *Werther*. Choristers have fainted onstage during crowd scenes and have been quickly carried off without a noticeable ripple in the flow of action.

The stage manager's report, a succinct little morning-after accounting of each performance, is more fun to read than most opera reviews. To read it, operas sound as catastrophe ridden as an Abbott and Costello movie.

"It was not a good night for the chorus," wrote the stage manager after a particularly bedeviled performance of *Semiramide*. One chorister fell sick and left the stage, others made late entrances, and yet another was revealed on his hands and knees searching for a contact lens when a panel suddenly slid upwards.

After another performance the stage manager wrote, "A sense of animosity between the soprano and tenor was growing between the second and third acts. By the time the performance was finished, she was so piqued that she refused to bow with him. Given the situation, I decided to drop the main curtain after the staged bows."

It is a tribute to the richness of opera that most of these disasters are not even noticed by the audience.

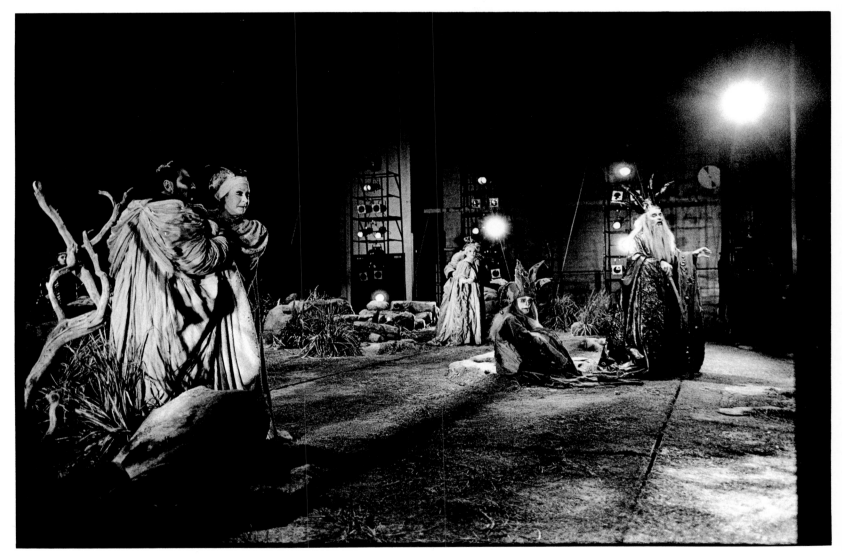

The dramatic Ponnelle production of *Lear* in the summer of 1981 marked the first time that San Francisco Opera audiences saw the back and sides of the stage, areas usually hidden by sets, curtains, and walls. This is the first act as the stage manager sees it from his desk at stage right.

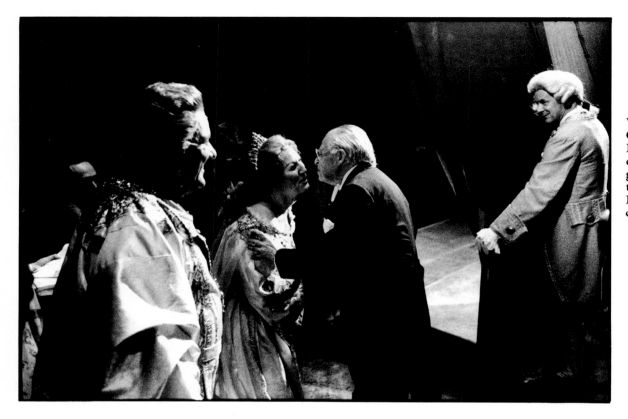

While French tenor Guy Chauvet stands by, San Francisco Opera general director Kurt Herbert Adler gives a congratulatory kiss to English soprano Anne Evans during the curtain calls for *Lohengrin*.

THE CURTAIN FALLS

By the time the curtain falls for the last time, the terror of the first few notes has been forgotten. Like a woman who forgets the pain of giving birth, singers forget the sweaty palms and the silent suffering in the wings. At the end, the fear has been erased by the roar of the crowd, and nothing is left but the curtain calls.

To the audience, curtain calls seem as formal and courteous as a minuet. Backstage, curtain calls often provide as much drama and comedy as the opera itself. The director plans the curtain calls sometime toward the end of the rehearsal period, guided by some time-honored operatic conventions: generally, a singer who will appear in subsequent acts does not take a solo bow. Only singers who appear in an act take bows at its end. After a group bow, the women depart first. The leading lady brings the conductor on unless the conductor is a woman, in

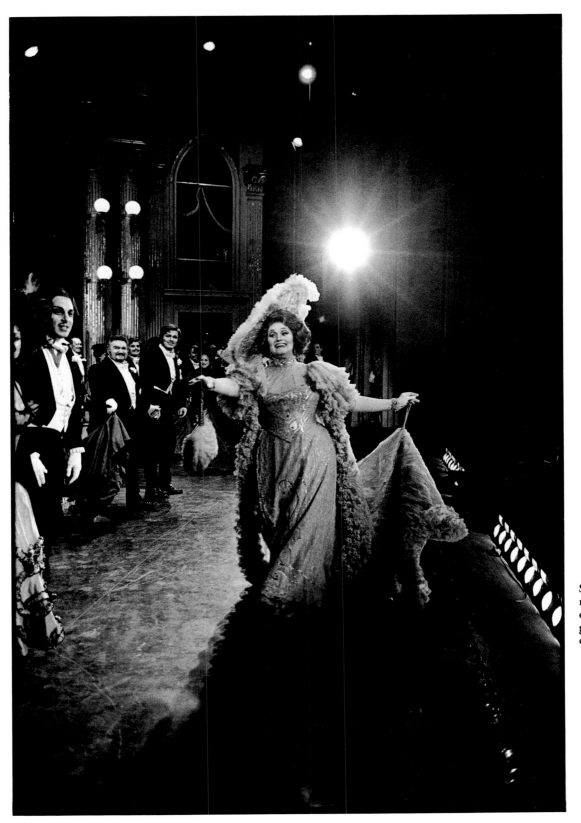

Soprano Joan Sutherland,
radiant after a performance
of *The Merry Widow*,
gestures for the conductor
during the curtain calls.

which case the honors are done by the principal male singer. The person in the title role always takes the last bow.

In spite of the traditions, curtain-call decisions are tricky. Singers take their bows in the order of the importance of their roles, saving the best for last, but the relative importance of roles may be a matter of some disagreement. Occasionally the issue can be settled by letting singers alternate the privilege of the final bow; that way, the role of Leonora is the most prestigious after act one of *Il Trovatore* and the role of Azucena, after act two.

Curtain calls are not always rehearsed. Partly, that is a matter of insufficient time in the frantic rush toward opening night. However, it is also an attempt to avoid disputes with singers unhappy about the scheduled order or the frequency of their bows. The schedule of curtain calls placed in each singer's dressing room is intimidatingly marked "Approved by the General Director," but that does not prevent vehement protests from singers who feel they are being mistreated. San Francisco opera staff members still giggle about the soprano who was so convinced that the scheduled curtain calls were insufficient for the audience response that she tried to crawl under the scrim to take one more unscheduled bow.

Backstage feuds sometimes explode during curtain calls. For one mezzo, the final straw in her icy relationship with a notoriously difficult Italian tenor came when they went onstage after the second act to take a dual bow. He politely bowed her off the stage and stayed to take an unscheduled bow for himself. The well-publicized feud between Renata Scotto and Luciano Pavarotti climaxed with her nationally televised refusal to take a curtain call during *La Gioconda*.

Once the last curtain call has been taken, the backstage area empties rapidly. The fortunate few friends and admirers whose names have been put on a list by the singers are milling around outside the Green Room, the traditional, carefully guarded space that separates the front of the house from the backstage area. After the singers have had a few minutes to remove their makeup and costumes, the guests are allowed to visit dressing rooms and to stare curiously at the vast stage.

Outside the stage door, a crowd waits patiently to see the singers leave. Those waiting seldom have to stand around long; the singers hurry out into the night, off to dinner or to bed. Only on the last night of a production is there a slight delay. That night, everyone lingers on the stage a little longer, saying a few final thanks and farewells.

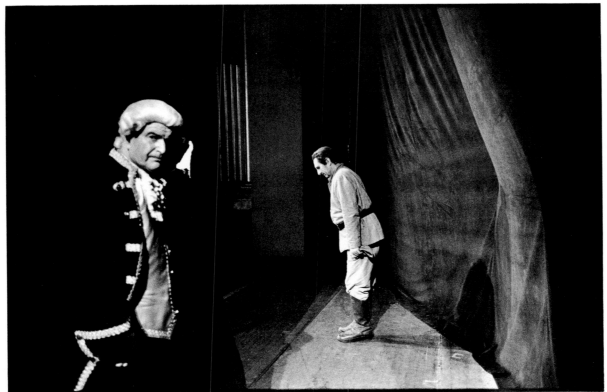

Curtain calls are sometimes almost as dramatic as the performance itself; bouquets were showered onto the stage when Renata Scotto took her bows after *La Gioconda* (above); Geraint Evans's final bow at the closing performance of *Wozzeck* (left) marked his last appearance as a singer at the San Francisco Opera. In San Francisco, the curtain is held back for the bows not by stagehands but by elaborately costumed volunteer curtain pages. Paul Klein, seen here, is a San Francisco lawyer who has been performing this ceremonial task for almost thirty years, rarely missing a performance.

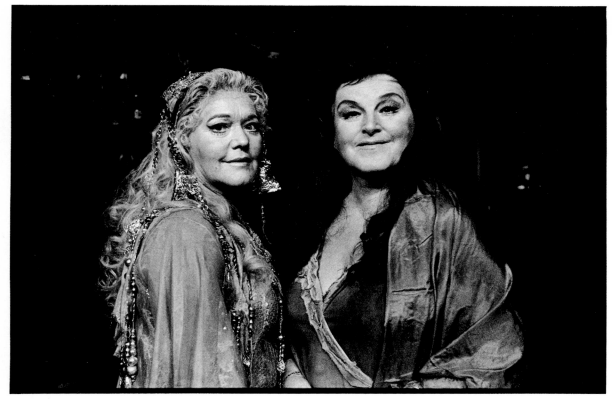

Leonie Rysanek and Birgit Nilsson wait backstage during curtain calls for *Die Frau ohne Schatten* in 1980.

Most of the singers have already packed their suitcases. The next morning they will be off to another city to repeat the whole process of making an opera.

After the last act the singers can finally relax and enjoy the adulation of the crowd; Montserrat Caballé (above) smiles almost impishly during her bows for a 1978 performance of *Tosca* and Leontyne Price (right) beams radiantly at the end of *La Forza del Destino* in 1979.

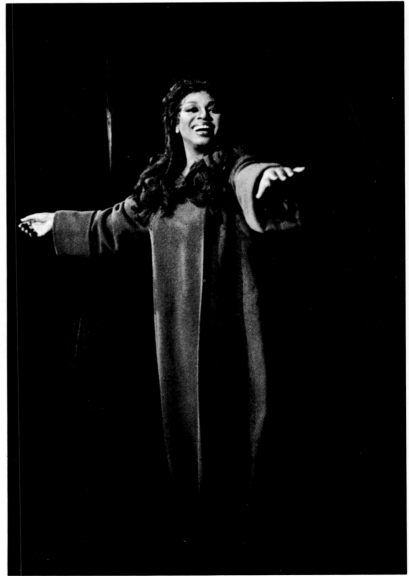

Opera stars often come to the dressing rooms to wish their fellow singers good luck on opening nights. Montserrat Caballé, in town for *Tosca*, came backstage on the opening night of *Werther* to talk to her fellow Spaniard, José Carreras.

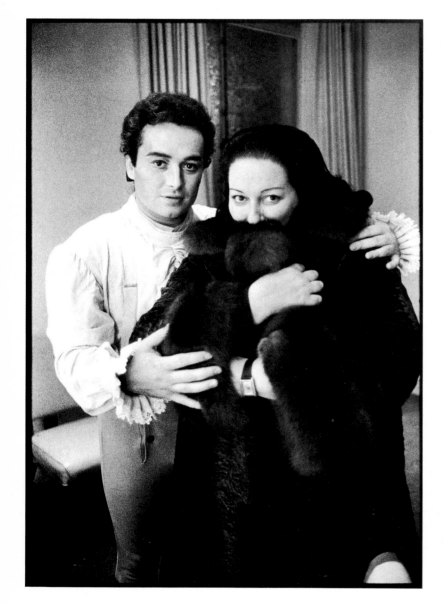

Placido Domingo and Carol Neblett pose for a photograph during the intermission of *La Fanciulla del West*.

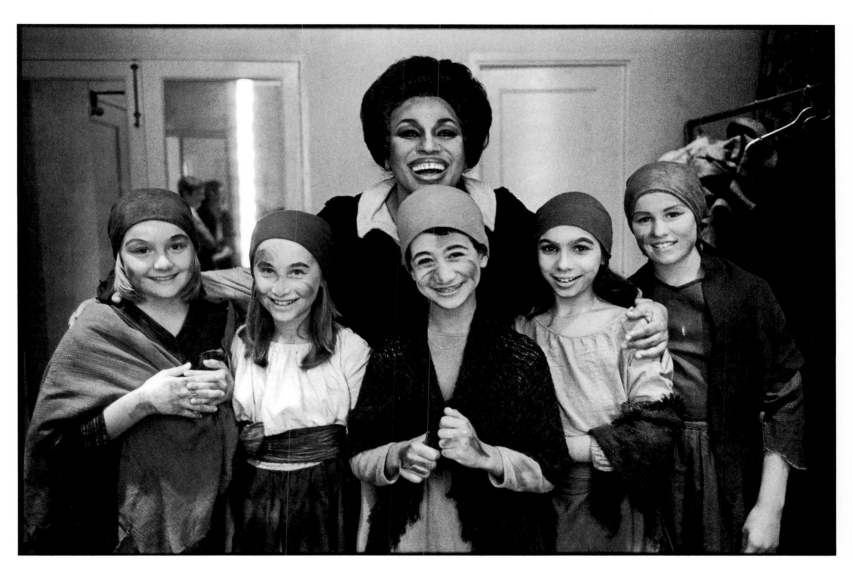

Members of the Girls
Chorus San Francisco,
costumed for *La Forza del
Destino* pose for a photo-
graph with Leontyne Price
during an intermission.

Dressers and makeup artists share the tension of the performance, both before the curtain rises and during the intermissions. Russian bass Evgeny Nesterenko waits in his dressing room with dresser Henry Kersh during an intermission of a 1979 performance of *Don Carlos*, in which Nesterenko made his American opera company debut as King Philip.

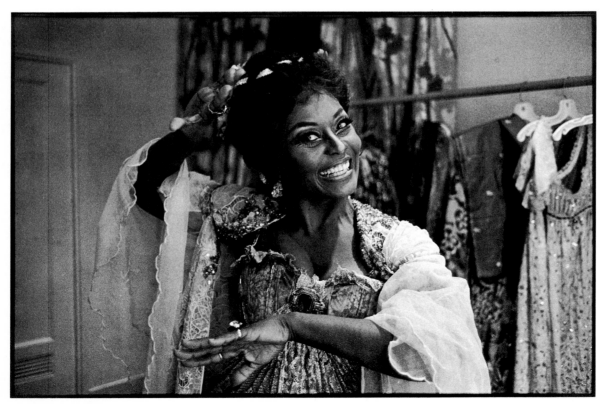

Shirley Verrett, her costumes glittering on the rack in her dressing room, smiles during an intermission of *Samson et Dalila*.

Mezzo-soprano Maria
Ewing waits in her dressing
room during the intermis-
sion of *Pelléas et Mélisande*.

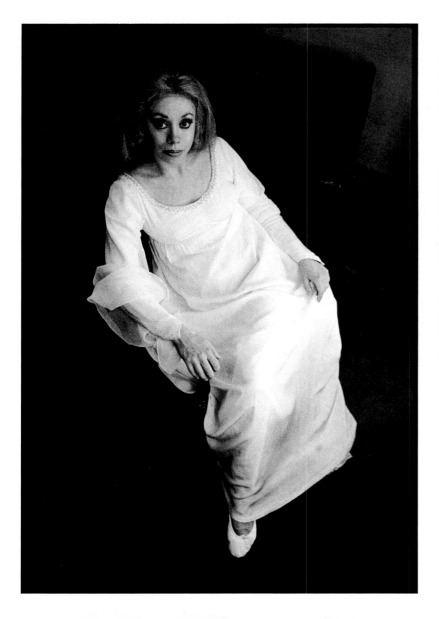

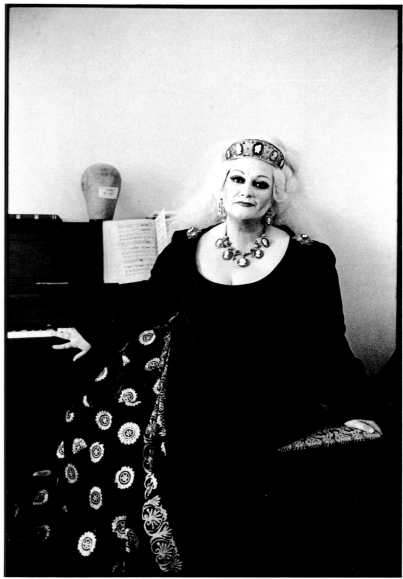

Montserrat Caballé,
wearing stark, pale makeup
designed to harmonize with
Pier Luigi Pizzi's highly
stylized white sets for a
1981 production of
Rossini's *Semiramide*, waits
in her dressing room for her
next entrance.

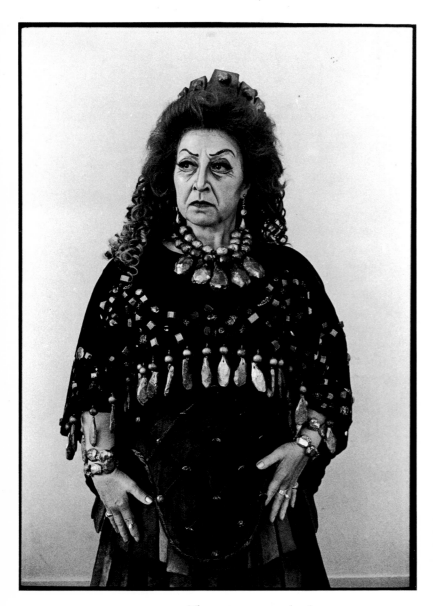

The costume worn by Anny
Schlemn as Klytämnestra
in *Elektra* is a dramatic
example of the larger-than-
life scale of opera costumes.

Italian baritone Benito di
Bella hams it up in his best
spaghetti-Western style
during an intermission of *La
Fanciulla del West*, in which
he plays Sheriff Jack Rance.

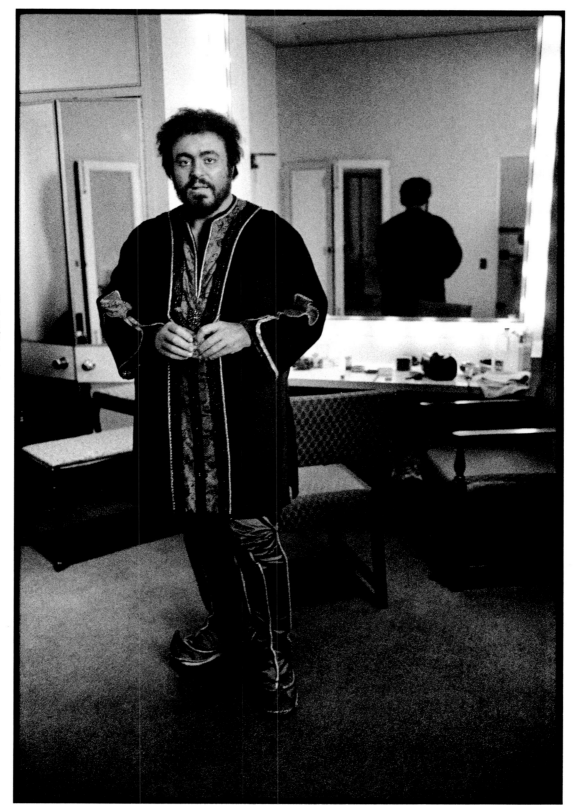

Luciano Pavarotti has described the intermission as a time when the singer is out of the battle for a brief spell but the war is still far from over. Here, he waits in his dressing room during an intermission of *Turandot*.

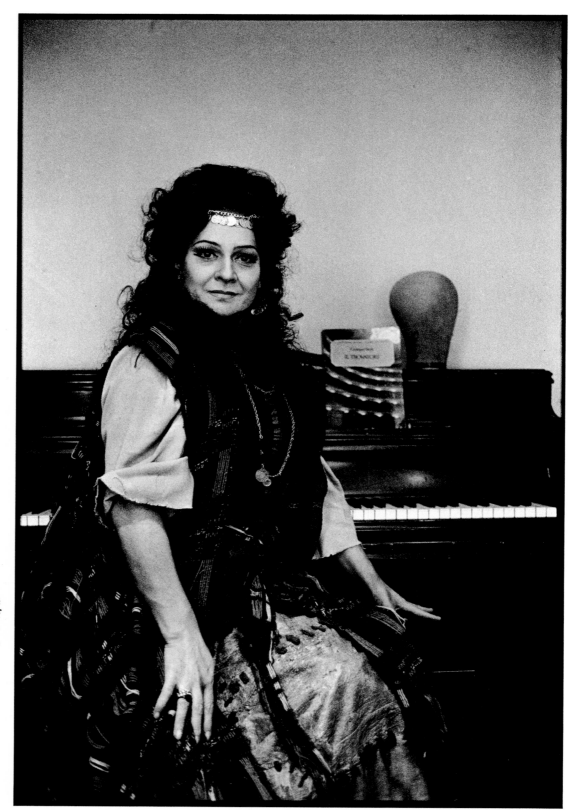

Fiorenza Cossotto sits at the piano, costumed for one of her most famous roles – Azucena in *Il Trovatore*.

Legendary soprano Magda
Olivero returned to her
dressing room carrying a
few of the dozens of
bouquets that were thrown
onstage after a memorable
performance of *Tosca* in 1978.

LIST OF PHOTOGRAPHS

<div align="center">

THE
INDEX

</div>

11/7

THE PHOTOGRAPHER AND THE AUTHOR

Documentary photographer Ira Nowinski grew up in
a musical family and has been a familiar figure backstage at
the San Francisco Opera since 1978, when he became one of the
company's staff photographers. His views of the great stars of the opera
world were taken using available light with a Leica M4, whose quiet
shutter enabled him to work unobtrusively during rehearsals and
backstage during performances. In the tradition of reportage
made famous by Henri Cartier-Bresson, his photographs
are not cropped or manipulated.

Joan Chatfield-Taylor is a San Francisco writer who,
after many years of opera going, became fascinated by the
hidden backstage world that produced such thrilling performances.
She spent almost a year observing the workings of the opera company.
During that time she interviewed dozens of members of the company,
observed hundreds of hours of rehearsals, hovered at the shoulder of the
stage manager in the wings during performances, stood on stage
as a light-walker during technical rehearsals, and did a brief
turn onstage as a supernumerary in *Carmen*.

BACKSTAGE AT THE OPERA

was designed by Howard Jacobsen, Fairfax, California.
The manuscript was edited by Carey Charlesworth.
The text was set in Galliard and Neufville Futura
at Type by Design, Fairfax,
by Michael Sykes and Sara Schrom.
The mechanicals were prepared by Craig DuMonte.
The title display is L&C Hairline.
Duotone plates were prepared and printed
by Dai Nippon Printing Co., Ltd.,
Tokyo, Japan.